What Now?
The Politics of Listening

Edited by Anne Barlow

black dog
publishing
london uk

Contents

Introduction

Anne Barlow

What Now? The Politics of Listening is the first in a series of three books, published in conjunction with Art in General's annual What Now? symposium running from 2015 through 2017. Conceived as a way to discuss timely and critical issues in the field, the What Now? symposium is organised by Art in General in collaboration with the Vera List Center for Art and Politics, New York, and since its inception, has covered the topics of Collaboration and Collectivity, 2014, and The Politics of Listening, 2015.

This publication reflects on the 2015 symposium that examined the idea of listening as a political act, a pedagogical process and a protocol for engagement. While the related topics of art and politics, sound art, and social practice have been the subject of various conferences, exhibitions, and publications in recent years, the focus of this symposium was inspired in part by issues that artists addressed in Art in General's 2014–2015 New Commissions programme.[1] The importance of "listening" also emerged as a subject that merited a deeper investigation during the inaugural symposium What Now? Collaboration and Collectivity.

The symposium What Now? The Politics of Listening took the form of four panel discussions: An Analysis of Listening; Taking Listening Seriously; Fact, Fiction, and the In-between; and Listening Across Disciplines: A Call to Action. While its thematic focus was not sound art per se, the symposium was nonetheless constructed as something that could be experienced not only through presentations and discussions, but also through film screenings, audio works, sound installations, and workshops. These experiences included *Moments of Silence*, 2014, by Bigert & Bergström; *The Narma Tapes: Polyphony and Politics in the Postwar,* 2015, by ESTAR(SER); *The Revolutionary*, 2010, by Iman Issa; *Blues Speaker [for James Baldwin]*, 2015, by Mendi + Keith Obadike; and *Ping-Pong Drawing*, 2015, by Wato Tsereteli. Rather than directly reproducing the programme, this book brings together a selection of transcripts from the symposium alongside newly commissioned essays and illustrated "inserts" that reflect on the nature of the event and the breadth of issues covered.

The first group of texts revolve around an analysis of listening, from a scientific definition of the term to perspectives on listening that are shaped and informed by diverse social, cultural, technological, and spatial considerations. In his contribution "Where Listening Begins: The Inner Ear", AJ Hudspeth notes that "hearing and listening are not the same thing, but hearing is the necessary first step towards the deeper process of listening, which also involves conscious attention and interpretation". During the symposium itself, this emphasis on "conscious attention" segued into a participatory activity led by ESTAR(SER), *Listening to understand, listening to forget: An exercise*, echoes of which can be seen in their insert, "The Narma Tapes: Polyphony and Politics in the Cold War". The definitions and interpretations of hearing and listening—and of "active" versus "passive" listening—are further explored in Christoph Cox's essay "Listening as Agon in the Society of Control", in which he challenges the idea of "hearing" as "merely natural, animal, and passive", and "listening" as "properly cultural, human, and active", leading us to consider our capacity for recognising different kinds of intelligences, and how we could incite new forms of receptivity.

In their foreword to an evolving essay on the subject, Grégory Castéra and Sandra Terdjman, co-founders of the artistic institution Council, introduce *Tacet, or the Cochlear Vertigo*, a project that aims to open up new dimensions within the concept of "listening" by exploring sound perception among profoundly deaf persons. To frame this project (one of Council's long-term investigations into specific "inquiries"), Castéra and Terdjman outline an

interdisciplinary methodology that brings together researchers from the areas of sound studies, deaf studies, sound art, neurology, architecture, translation, design, literature, music, sound engineering, and the visual arts as a means of examining sometimes oppositional approaches to the subject.

The complex relationship between fact and fiction in relation to interpretative listening, media communication and acts of testimony, translation, and redaction is one that several contributors address. In "What is the Shape and Feel of the In-between?" Lauren van Haaften-Schick examines the relationship between fact and fiction with particular regard to the law, which she describes as the "product of culture, and the human" and as such encompasses "material truths, pure convenient lies, wavering statements, and imperfect memory". In relation to witness testimony, she further notes that, "a remembered fact, and the recording and future emission of it will always be subject to the alterations that are a by-product of its human processing". This refuting of the possibility of an objectively definable shared experience provides an interesting counterpart to Naeem Mohaiemen's text "What we mean when we ask permission". Here Mohaiemen reflects on the dilemma of artistic responsibility that lies in editing or "reframing" the real life stories of the male protagonists in his most recent films— noting that their reactions ranged from an acceptance of his interpretation to a resistance to having their narrative told in a voice other than their own. Also exploring the construction of narrative—in this instance the stories of Puerto Rican political prisoner, artist and writer Elizam Escobar, artist Carlos Irizarry, and Pablo Díaz Cuadrado—Beatriz Santiago Muñoz describes the various "tricks" she uses in her working practice to open up, and at times complicate, the ways in which she engages with such narratives, and with language itself.

In "How To Do Things With(out) Words", Joshua Craze speaks about his long-term analysis of redacted documents from the American War on Terror, and the shifting of his interest from merely

"uncovering" what is hidden within them to the system of concealment itself. These ideas around "presence" and "absence" bring to mind Robert Sember's words about the importance of being able to "listen for what is left out, and why", as well as Lawrence Abu Hamdan's commentary on the complex relationship between—and the various implications of—the right to freedom of speech and the right to remain silent.[2] In a world in which the production and reception of information encompasses print and digital media, spoken narratives and the ever-expanding space of social networks, contributors also consider how one can listen with agency and intent in an environment characterised by such an onslaught of data. In her essay "Algorithmic Listening and Communicative Democracy", Seeta Peña Gangadharan looks at how new technologies transform what she calls the communicative diversity of modern society and the capacity of the media of communication to "amplify or inhibit people's ability to speak and listen with reciprocity and respect". Exploring issues such as data profiling, listening as a form of surveillance, scholarly writing on infrastructures of "internal" versus "external" exclusion, and algorithmic listening with particular regard to historically marginalised groups, Gangadharan posits that communicative democracy may well remain a myth.

Interested in the changing nature of testimony in relation to algorithmic technologies, border control, medical sciences, and surveillance, Lawrence Abu Hamdan considers the ramifications of "forensic listening" in legal investigations —a process that considers not just what is said, but how it is said, as well as the sonic environment that contextualises a voice. Through three powerful case studies in which he examines how the stakes and conditions of speech have changed, as well as the diminishing capacity of one's right to remain silent, Abu Hamdan concludes that the "politics of listening" today is not so much about advocacy alone, or giving people a voice, but rather something that should attempt to "redefine what constitutes speech" itself.

Tackling the notion of "listening with intent", and how to position listening as a political act, several contributors consider what new possibilities might arise when listening becomes a more purposeful activity. This practice is one that is advocated, among others, by Robert Sember, a member of the collective Ultra-red. In "Strong People Don't Need Strong Leaders: Intentionality, Accountability, and Pedagogy", Sember looks at how intentional listening can assist with political organising and aid in addressing the concerns and interests of particular constituencies. Examining aspects of collectivity—such as intentional listening, accountability, listening protocols, and pedagogy—Sember stresses the importance of continuing to enhance knowledge through the enacting of these behaviours, and posits some ways in which political listening can be put into practice. Pablo Helguera similarly discusses the inherent challenges of listening within socially engaged art practice in "Listening to the Converted: Critical Looks at the Social Algorithm". Noting the shortfalls of many well-intentioned projects that aim to engage individuals or communities, but that lack the flexibility to respond in meaningful ways, Helguera posits that, "listening is irrelevant if what has been listened to is not assimilated into the very structure of the work".

In terms of the work of the collective Postcommodity to which he belongs, Kade L Twist speaks about how procedures in listening can assist a constituency to find its own power and solutions to diverse sets of problems. Referring to Postcommodity's project *Repellent Fence*, a two-mile-long installation made of ten-foot-diameter vinyl spheres floating above the Mexico-US border, Twist describes how their commitment to community self-determination was activated through a long, bureaucratic process that necessarily involved "listening, respect, reciprocity, patience, interdisciplinary diversity, and community driven strategies". Speaking about the importance of such ideas within the realm of social policy, Laurie Jo Reynolds similarly cites the importance of listening in Tamms Year Ten (TY10), the legislative campaign to reform or close the supermax prison in Illinois. Describing lobbying as "listening with political consequences in mind", Reynolds recounts the sometimes agonistic process of lobbying for the prison's closure, as well as the alternative and potentially transformative ways of dealing with justice and rehabilitation that can arise through the process of listening.

The contributions to this publication present just some examples of how artists, scientists, and educators are examining listening as an expanded field in relation to pressing cultural, political, and social issues. Whether traversing various disciplines and areas of inquiry, or actively investigating how artistic practices can meaningfully engage and interact with individuals, communities, and civic society, their work explores the way in which a radical questioning of the processes of how we listen can challenge, inform, and potentially change, the nature of the conversation.

1. Recent conferences, talks, exhibitions, and books include: Listening, Hayward Touring Curatorial Open exhibition: BALTIC Centre for Contemporary Art, the Bluecoat, Site Gallery, and Norwich University of the Arts, September 2014–February 2016; 2014 Creative Time Summit: Stockholm, November 2014; HLYSNAN; The Notion and Politics of Listening, Casino Luxembourg–Forum d'art contemporain, 17 May–7 September, 2014; 3rd International Sound Art Curating Conference, University of London, Goldsmiths / Courtauld Institute of Art, 15–17 May, 2014; Sexing Sound: Music Cultures, Audio Practices, and Contemporary Art, The Graduate Center, CUNY, New York, 21 February, 2014; SonicWorks, DiverseWorks Artspace, Houston, Texas, 11 January–1 March, 2014; Center for Experimental Lectures: Christoph Cox and Sergei Tcherepnin, Recess, New York, 7 January, 2014; Soundings: A Contemporary Score, Museum of Modern Art, New York, 10 August–3 November, 2013; The 13th Istanbul Biennial Public Program: Public Alchemy, February–November 2013; Suzanne Lacy, Between the Door and the Street, Creative Time and the Brooklyn Museum, New York, 19 October, 2013; Word. Sound. Power., Tate Modern, Project Space, 12 July–3 November, 2013; Carlyle, Angus and Cathy Lane ed, *On Listening*, Uniformbooks, 2013; Apter, Emily, *Against World Literature; On The Politics of Untranslatability*, London: Verso, 2013; 2012 Whitney Biennial, Arika: A Survey is a Process of Listening, Whitney Museum of American Art, New York, 1 March–27 May, 2012; Kelly, Caleb, *Sound*, Whitechapel: Documents of Contemporary Art, London and New York: MIT Press, 2011; Organized Listening: Sound Art, Collectivity and Politics, Ultra-red, Parsons' Aronson Gallery, The New School, New York, 17–30 November, 2010; Voegelin, Salome, *Listening to Noise and Silence: Towards a Philosophy of Sound Art*, London: Bloomsbury Academic, 2010; Several Silences, The Renaissance Society at The University of Chicago, Illinois, 26 April–7 June, 2009; Every Sound You Can Imagine, Contemporary Arts Museum Houston, 3 October–7 December, 2008.
2. Ultra-red, "Notes on the Protocols for a Listening Session (Glasgow Variation)", Carlyle and Lane, *On Listening*, p 33.

Mechanics

Methods

Metaphysics

Where Listening Begins: The Inner Ear

AJ Hudspeth

"I am a physiologist, not an artist, so I am not here to tell you where listening begins; instead, I will be talking about hearing. I recognise full well that hearing and listening are not the same thing, but hearing is the necessary first step towards the deeper process of listening, which also involves conscious attention and interpretation. I would like to tell you about what our ear does while we are hearing and in particular the surprising features of the ear, that were recognised only recently, in which the ear distorts what we hear and greatly amplifies and otherwise conditions the things that we listen to.

Here is a sample of sound that is recorded and then presented in two ways. At the top is an electrical measurement that you would get if you just took the signals coming out of this microphone: in essence, a series of syllables. This is a two-and-a-half-second-long record, and below it is a sonogram. This is the same information except now it has been decomposed into different frequencies or tones, with the higher frequencies near the top, up to 10 kilohertz, and the lower frequencies towards the bottom. This particular snippet of speech is my voice and it is actually the last line of Dylan Thomas' poem "Fern Hill". The last stanza reads:

> Oh as I was young and easy in the mercy of his means,
> Time held me green and dying
> Though I sang in my chains like the sea.

In looking at the part "though I sang in my chains like the sea" you can readily see the different speech components decomposed into their frequencies. Vowel sounds—"ooough", "aaang", "aains", and so on—use low frequencies. The high frequencies are the consonants: "sssang", "ccchains", "sssea", and whatnot. And this is what your ear is doing all the time: it will do it in fact several hundred thousand times in the course of this symposium as you listen to different voices. You will be constantly fragmenting the sounds that you hear into these different frequency components, into these different tones. That information then has to go into the brain and from it, the brain has to interpret exactly what you have heard.

The place that this occurs is of course the ear. There is an external ear that captures sound, and a middle ear, with the three smallest bones in the body, that conveys vibrations into the inner ear or cochlea, which is a coiled, snail-like structure. It was very beautifully diagrammed in 1884 by Retzius, an early anatomist who worked on its structure. The name "cochlea" is in fact Greek for "snail shell" for obvious reasons. You can imagine how this organ works by supposing that you can unroll the snail, in which case you would get a straight tube about an inch and a half in length. That tube is full of liquid, but down in the middle of it there is an elastic partition rather like a rubber band. When a sound is heard, it vibrates the eardrum. When the eardrum is pushed inward, the three little bones move to your right, the last bone acts as a little piston and pushes on the liquid in that space, which in turn pushes the rubber band called the basilar membrane—the red stripe— downward. When the sound pressure decreases, the opposite happens and the membrane moves up. So if this band were homogenous—if it were like a guitar string—the membrane would simply vibrate up and down in one place just as a guitar string does. But in fact it is a like magical string:

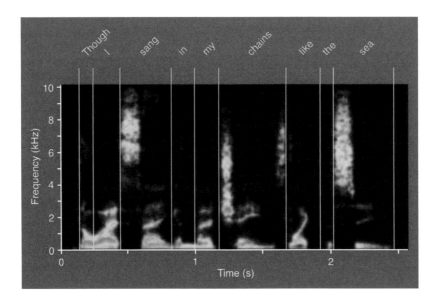

A sonogram shows the range of frequencies—sound tones—present in a human voice, here that of the author reciting the last line of Dylan Thomas's poem "Fern Hill". Each of the prominent vowels in "though", "sang", "my", "chains", and "sea" is represented by several low frequencies. The consonants of "sang", "chains", and "sea" appear as high frequencies. The cochlea decomposes speech sounds into their frequency components and forwards electrical signals into the brain, which uses the information to determine what has been heard. Time is represented in seconds along the horizontal axis and frequency is shown in kilohertz, or thousands of cycles per second, on the vertical axis. The loudness of each frequency component is portrayed by its colour, progressing from blue for the weakest sounds to red for the strongest.

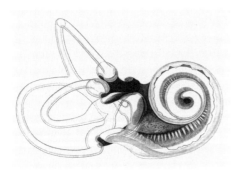

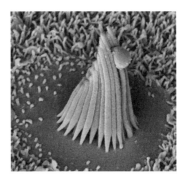

A drawing by the great anatomist Gustaf Retzius shows the human inner ear. At the right is the coiled cochlea, which captures the energy in sounds and converts it into electrical responses that are sent to the brain along the nerve fibres that radiate from the cochlea's core. Low frequencies excite the fine tip of the cochlea whereas high frequencies activate the broad, flared base; other frequencies are represented sequentially between those extremes. The remainder of the inner ear is the vestibular labyrinth, which includes three semicircular canals—the sites of our sensitivity to turning movements—and the utricle and saccule—organs for the perception of gravity and straight-line motion. Credit: Retzius, Gustaf, *Das Gehörorgan der Wirbelthiere. Morphologisch-histologische Studien. Band II. Das Gehörorgan der Reptilien, der Vögel und der Säugethiere*, Stockholm: Samson & Wallin, 1884.

A representative hair bundle from the ear of a frog consists of about 60 stereocilia that protrude by three ten-thousandths of an inch from the smooth top surface of a hair cell. When stimulated by sound, each of these mechanically sensitive "feelers" pivots at its base, setting up an electrical response in the cell. Note the progressive increase in stereocilia length from left to right; deflecting the bundle in that direction excites the cell. At the bundle's tall edge stands a single kinocilium with a bulbous tip. This component is important in organising the bundle's elegant structure during development.

one end is rather broad and floppy, and the other is rather taut and narrow. So it is like a string that changes from the low string on a bass to the high string on a violin along its length. As a consequence, different frequencies make it vibrate in different places. The lowest frequencies vibrate at the tip, while the highest frequencies vibrate at the base. The other frequencies in-between are all mapped out in a nice straight way. The value of this is that if you listen to a complex sound like my voice, the low frequencies will cause a vibration at the top, the middle frequencies in the middle, and the high frequencies at the bottom. So this system is constantly breaking down the complex sounds that I showed you into different frequency components, into different tones. It is undoing what a piano does, in that a piano takes different pure tones made by the strings, and combines them into a mellifluous sound. The cochlea takes that complex sound and then spreads it out again, causing vibrations at different positions.

There is a more graphic demonstration that begins with a schematic diagram of the eardrum at http://lab.rockefeller.edu/hudspeth/cochlear_movie_popup. On the far side we see the coiled cochlea, which is then schematically uncoiled so that you can see how the different frequencies are represented. What amazes me is that this is exactly what is going on in your own ear as you listen to the *Toccata and Fugue*: each of your cochleas is showing vibrations along its length.

That information, that vibration owing to different frequencies, then has to be somehow picked up and conveyed to a series of nerve fibres. Each of these blue lines represents a nerve fibre that is carrying information about a particular tone. High frequencies are associated with the base; low frequencies are associated with the tip. Along the length of this elastic band, the basilar membrane, are some 16,000 cells called hair cells that actually change the vibrations into electrical signals that the nerves then carry into the brain. So if you listen to one particular tone, say middle C, there will be a vibration in a particular place. Just that group of hair cells will be excited, just those nerve fibres will be excited. And that pattern of activity signals that I am listening to middle C; how hard the nerves are firing says how loud the middle C happens to be.

Going back to the Dylan Thomas line, the word "chains", begins with a "ch" sound, a consonant. That will excite relatively high-frequency fibres at the cochlear base. Then the vowel, "aains", will excite low-frequency cells in the middle of the cochlea. And finally that "sss" at the end is again high-frequency and will excite the high-frequency nerve fibres. So all the time in your cochlea, the different nerve fibres are firing signals that go into the brain, and the brain, at the other end of all of those nerve fibres, has to understand what is being heard on that basis.

Hair cells have nothing to do with the kind of hair that I am missing. They are called hair cells because each has at its top a little cluster of filaments, fine protrusions called the "hair bundle". Each of these cells is about one thousandth of an inch tall, and has a nucleus. It has all the usual cellular features and makes connections with nerve fibres that carry the information to the brain. If we look down on the cell from above, we see a series of these cells in a beautiful pattern with hair bundles sticking up like little antennae to receive mechanical stimulation.

A schematic diagram shows what happens during stimulation. When a living hair bundle is pushed with a glass rod, the whole thing moves as a unit and sways back and forth. And this is what is going on all the time as you listen. Those vibrations, each at a different frequency, cause the relevant hair bundles to jiggle back and forth. At the low-frequency end, at the top of the cochlea, they jiggle back and forth at 20 times a second; at the high frequency end they jiggle back and forth 20,000 times a second, and all those in-between jiggle at their respective different frequencies.

How is that information turned into electrical signals? It is a very simple mechanism. At the top of each of the tiny processors is a fine thread, a chemical strand made of four protein molecules that acts just like a little string. When the hair bundle is deflected, the sliding of adjacent processes pulls on the string and the string pulls little ion channels open. The strings get tense, pulling on the little molecular gates and opening them; now ions like potassium or calcium can flow in and change the voltage in the cell. So it is the simplest imaginable system, but it has a couple of virtues. It is extremely fast because there is no fancy chemistry involved in pulling the door open and it is therefore able to respond to a very high frequency. And secondly it is extremely sensitive: a truly atomic level of force and displacement is enough to open these channels, so we can actually hear everything down to the vibration of the water molecules within our ears. Our ears are that sensitive. We cannot hear anything fainter because it is drowned out by the cacophony of all those bouncing molecules.

This way of doing business has an interesting side effect which appears in the arts, particularly in music, in that such a system distorts sound. The way it distorts it is that every time the hair bundles move, a little bit of energy is taken up by opening the channels, and every time it goes back, that energy is restored. This is a non-linear system: it is asymmetrical in moving to and fro and as a consequence it makes a distortion. The distortion was first noted by the violinist Giuseppe Tartini in 1714. He recognised that if he played two frequencies on his violin—and I'll call them F1 and F2, just two different frequencies of sound, two tones—he could hear not only those frequencies and their harmonics, but he also could hear sounds he knew his violin could not be making, namely, the sum of those two frequencies or weird things like twice the lower frequency plus or minus the higher. He called these "the devil's tones", and although he did not know what to make of them, he made some use of them in music. And more recently György Ligeti and Karlheinz Stockhausen have both made compositions in which these strange tones are heard even though they are played by no instrument.

To demonstrate this, I will play two different frequencies: first a constant frequency F1, then the constant frequency F2, and then the exact same two things simultaneously. It turns out that the most prominent of these so-called "distortion phantom tones" is twice F1 minus F2. So twice F1—which has not been played—would be a relatively high frequency. Twice F1 minus F2 starts out with a small difference and then gets progressively greater. So the point of this is, in playing a constant tone and a descending tone, if you listen, particularly near the end, you will hear an ascending tone—and that ascending tone, I promise you, is not there! This is a neat trick. A normal ear does that because it has the distortion I showed you, and this same test

can be done on a newborn child, in fact this is now done by law in most states when a newborn is still in hospital. A health professional can play two tones into an ear and look at a meter, which says "good ear" or "bad ear", depending on whether the distortion is coming back out of the ear. So you can tell at one day of age if a child's hearing is more-or-less normal or not. This is really valuable because it used to be that some kids with genetic hearing loss did not get noticed for perhaps five years, until they went to school. Now we know if there is a problem from the day they are born, and they can either have surgery, learn sign language, or perhaps get a cochlear prosthesis or implant. In any event something can be done to remediate the problem before the child begins to acquire language, or before he or she becomes learning-delayed.

The striking feature of hearing which we did not anticipate is something called the "active process". It turns out that the ear is not just passively picking up sound and sending signals to the brain, but that the ear is interpreting the sound in several different ways. The two most prominent ones are amplification and frequency tuning. When our ears capture sound they amplify the sound itself—the mechanical vibrations—by a hundred to a thousand-fold. A passive ear would have a weak response but an active ear is a hundred times as sensitive, and is also strongly frequency-tuned. That is, each of those hair cells, each of those elegant little things with the organ pipes on top, responds very sharply to a particular frequency. If, on the other hand, the hair cell were not alive, if it were passive, then the response would be broad. Even if you turned the sound up a hundred times you would still get very poor tuning. This is in fact what happens to us as we lose our hearing. Most people do not become totally deaf overnight; instead they become "hard of hearing". What is happening is that their amplifiers are blowing out: they lose about 99 per cent of their sensitivity because they can no longer amplify and have a harder time discriminating sounds without this sharp tuning. This is why hearing aids are not so successful. A hearing aid can amplify the sound, but it cannot reproduce the tuning that is normally present, so even with a good hearing aid, people hear things loud enough to detect them, but they can no longer carefully discriminate different frequencies of sound.

All these processes originate in the hair bundle. In fact, if you make recordings and analyse them, you find that different bundles oscillate in different ways: some fast and almost metronomically, some more slowly, and some very erratically. The hair bundles have the capacity to do work: they have energy that they can use to oscillate spontaneously or to amplify incoming sound as they do normally. In fact the system can adjust itself. If you are in a loud environment, you don't need the amplification, so the hair bundle turns itself down. But if you are in a very quiet environment, it turns itself up until you can hear the figurative pin drop. In fact, if you go into a sound booth with no sound at all, the system goes so far that it becomes unstable, just as a public-address system would: if we turned the gain up too far it would begin to howl or oscillate spontaneously.

This behaviour of hair bundles produces so-called spontaneous otoacoustic emissions, again a great surprise to us. 70 per cent of normally hearing people have sounds coming out of their ears in a sound booth.

It is very typical to have five or six of these emissions, with the world record being about 30. Some people have none at all, and most of us have two to three. So if we took any of you back to the lab and put a microphone in your ears, the odds are 70 per cent that one or both of your two ears would produce one or more sounds continuously. These sounds are different to your two ears: the left will be different from the right. The sounds are stable throughout life unless something bad happens, like loud music or some kind of accident or artillery fire. People have even thought of using the sounds for bio-identification—like retinal prints or fingerprints—as a way of detecting a particular individual.

I also want to mention what happens when hearing is not normal. There are about 300 genetic conditions that cause deafness, sometimes at birth, sometimes later in life, by causing deterioration of the hair cells. There are also various legitimate drugs that can destroy these cells, such as some aminoglycosides (gentamicin, neomycin, and streptomycin, for example). When you take such drugs systemically in large amounts, which you sometimes have to do for bacterial endocarditis or another life-threatening infection, those drugs can destroy hair cells. Cisplatin, which is the major chemotherapeutic for ovarian cancer, can have the same effect. Many women suffer from this; their lives are spared but they lose some or all of their hearing as a result of having to use this drug. With acoustic trauma, loud noises can cause damage, whether from the environment, industry, military activity, or even from music. Any of these things can gradually whittle away at one's hearing. There is also a phenomenon called presbyacusis, the deterioration of hearing with age. "Presby" means old men, so presbyacusis is the hearing of old men. This is the gradual decline of the hearing faculties seen in most industrial societies. This is probably a result of the deterioration of small blood vessels, just like the ones that cause blindness, heart problems, and so on, and from daily loud noises.

We are interested in what can be done about this hearing loss. In humans, the hair cells are not regenerated. Like brain cells, you get one set, and that is it. If you lose a hair cell, you have lost sensitivity to that particular frequency, for good. But other animals are not so unfortunate. If we examine the ear of a chicken that was taken to a rock concert where its ear was devastated we see that there is a scar running across the middle, but within a few days, miniature hair bundles erupt from that area, and they will grow and replace the missing cells. So we would like to know why humans and other mammals cannot do the same thing. In fact, just to give you one brief notion about how research works, our particular group is working with the larval zebrafish. These are little dime-store fish that can grow in a laboratory in large numbers. Along the animal's side are little organs lit up with fluorescence, each of which contains clusters of hair cells. And the nice thing is you can look at these in the cells in living fish and watch new hair cells form. We can identify precursors that divide into two cells, each of which will become a new hair cell. They will be used by the fish for a few weeks and then die and be replaced. So we want to know more about the biochemical programme that allows the replacement to occur and how can we reactivate that programme in ourselves so that we can get our hair cells back.

In the meantime, there is an interesting therapy: the cochlear implant or cochlear prosthesis. I mentioned that in a normal ear you have 16,000 hair cells and when any group of them is activated, the associated nerve fibres carry information into the brain. If you lose all your hair cells as a result of one of the problems I mentioned before, what can be done? We can take advantage of the fact that the nerve fibres are laid out in a neat array. Imagine that you put a little wire with an electrode on particular nerve fibres, and then stimulate them electrically. Those nerve fibres would send information into the brain, which would think "I'm hearing middle C". That is what a cochlear prosthesis does: it is inserted into the ear, bending into the cochlea and spiralling around the area where no hair cells are left, but where nerves still survive. A plastic implant with pairs of electrodes can shock the nerve fibres. Each pair will shock the cochlea in a different place and therefore represent a different frequency. A person wears an external device, often on the frames of eyeglasses, that captures the sound and breaks it down into different frequencies. They are then magnetically broadcast across the skin, picked up by the wires inside, and relayed to the electrodes so that different nerves are successively shocked.

If I play you a bit of recorded speech in which I have filtered out all the information except five particular frequencies, it will be unintelligible. The very first prostheses had only around five or six frequencies. In a sample with ten channels, you can begin to get a few words. In a sample containing 20 channels, which is about what a contemporary device has, you can identify certain words. 300,000 people in the world who were totally and utterly deaf, have had hearing restored through a cochlear prosthesis. It is also the case that it changes your brain: people can very rapidly accommodate to these devices and learn to use them, so they are very effective.

What I have discussed here is not listening, but hearing. The information coming into the ear gets processed in the brainstem, the lower portion of the brain, and then gets funnelled up to an area called A1 on the surface of the cerebral cortex. From there it radiates out into the surrounding higher areas, which we understand very poorly, in terms of the next steps of how this information gets converted into a useful form for thinking or taking action. Some of the information is funnelled through Wernicke's area, an area that is involved in the perception of speech and the understanding of speech. People who have had a stroke in that area have difficulty understanding speech even though they can still speak fluently. Information flows from there also to Broca's area, which is the inverse. Broca's area is involved in the production of speech so people with a Broca's area stroke can understand speech perfectly well, but they cannot produce fluent speech. All the rest of the brain is where the listening occurs. Once things have gone through this relatively simple stage, they go to the level of consciousness, to the level of analysis and interpretation that I believe is what this conference is about.

The Narma Tapes: Polyphony and Politics in the Cold War

ESTAR(SER):

The Esthetical Society
for Transcendental and
Applied Realization

ESTAR (SER)

THE NARMA TAPES:

POLYPHONY AND POLITICS IN THE COLD WAR

———◆———

Readers of the PROCEEDINGS OF ESTAR(SER) will already be aware of the considerable efforts made by various scholars, collectors, bibliophiles, and editors to sift the historicity of that peculiar body known as THE ORDER OF THE THIRD BIRD. Despite the labors of the ESTAR(SER) researchers, a great deal of uncertainty (and even some genuine confusion) persists concerning the nature and workings of THE BIRDS — a self-sequestering community that seems to function, at least in its modern incarnation, as a private association of adepts who convene to perform public and private rites of sustained attention to made things (often works of art). New documents bearing on the genesis, evolution, and practices of THE ORDER are continually coming to light, and we are pleased here to offer a sample from a new and interesting body of relevant materials. Details follow.

TEXT AND CONTEXT

The émigré Estonian sound engineer Rein Narma (1923-2011) played a significant role in the development of the 1959 Fairchild 670, a vaunted limiter/compressor that remains a cult artifact among audiophiles. His relationship with Les Paul and other jazz greats has been discussed elsewhere; his later work with the Ampex Corporation has been treated in a valuable oral history. Narma's apparent relationship with the Order of the Third Bird is less well understood, but there seems to be some evidence that he was involved with attentional practices very much like those familiar to associates of the Order, and that he may have been at the center of a community of like-minded practitioners in New York City in the late 1950s and early 1960s (See "The Hale Transcripts: Object-Oriented Ventriloquy and the Bay of Pigs," forthcoming in the *Proceedings*). It is this prior (speculative) identification that permits us to surmise that the artifact depicted opposite may have belonged to Narma, and may represent his acoustical handiwork. The audiotape labeled "Beckmann, MoMA, 12/19/1964" (and initialed "RN") contains nine minutes and three seconds of lyrical cacophony in three discrete "movements." Overdubbing and even (apparently) reverse playback characterize these challenging and layered recordings. Internal evidence, to be discussed in detail in a subsequent publication, suggests that this unprecedented acoustical source represents an elaborately manipulated *sound recording of six associates of the Order of the Third Bird engaged in a "colloquy."* The object? One of the Max Beckmann paintings on display at the MoMA exhibition that opened in mid-December of 1964. It is impossible to say with certainty what might have motivated Narma to experiment with so radical a treatment of the intimate exchanges among his companions, but a biographical note merits close consideration: at the close of the Second World War, Narma (a staunch anti-communist, whose family had suffered directly at the hands of the Soviets) found work with US forces in Western Europe, and subsequently served in an extraordinary capacity—as a sound engineer at the Nuremburg trials, where he helped maintain the IBM Hushaphone Filene-Findlay system. Radical for its time, these acoustically isolated microphones and headphones connected each listener with the appropriate translator across four languages. One can feel a pang of (imaginative) sympathy for the polylingual Narma under such conditions, obliged to listen, for hours, to such unsettling testimony—in English, French, Russian, and German. Did Rein Narma's life of unparalleled audiophilia (a concern with *how things sound*) represent, ultimately, a flight from a surfeit of unbearable content (the dreaded *what was said*)? More research is needed.

FIGURE: Back cover of the flat, square box (found in the W-Cache) containing one reel of quarter-inch magnetic audiotape. The tape preserves what appears to be a set of acoustic experiments made by Rein Narma in late 1964. The three lines of holograph text at center would seem to spell out (in the Nuremberg languages) three phases of an attentional "Protocol of the Listener"; a transcription is given overleaf. The German sentence at bottom inscribes the opening verse of Rilke's Duino Elegies (1923): "Who, if I cried out, would hear me among the Angelic Orders?" (Photo courtesy of Tasty Waives).

THE PROTOCOL OF
THE LISTENER

We have relatively little to go on in the reconstruction of this attentional exercise—only Narma's three multilingual exhortations. The italicized directions below represent an effort to interpolate missing details, and thereby to recover how "The Protocol of the Listener" (as we have chosen to call it) might have been activated in specific Actions of sustained attention to sound recordings like those found on Audiotape 12/19/1964—or other audio material.

Phase the first: attend. Close your eyes. Allow the sound to bring the image into your mind's eye. Consider it, in as much detail as its presence allows.

1. attend / hören / écouter / слушать

Phase the second: forget. Allow the sound to erase the image from your mind. It may dissolve; it may age to dust; it may go up in flames. There are many ways of forgetting.

2. forget / vergessen / oublier / забывать

Phase the third: remember. Allow the sound to bring the image back to you; see it again. It may have changed. Memory, sometimes, works that way.

3. remember / bedenken / souvenir / запомнить

At the conclusion of the Action, we imagine a moment of silence.

Listening as Agon in the Society of Control

Christoph Cox

Before we move too quickly to discuss "the politics of listening", I would like to offer some philosophical caveats aimed at reconfiguring the ontological field in which we understand "listening" and "the political". The question of listening seems to me to be fundamentally a question of interpretation, in the expanded sense in which Nietzsche uses the term. For Nietzsche, "to interpret" is to be confronted with a flow (of words, sounds, images, information, whatever) and to filter it in some way according to some set of interests or constraints. "The *essence* of interpreting", he writes, is "forcing, adjusting, abbreviating, padding, inventing, falsifying", and so on.[1] This, of course, is what the scholar does when she selects a particular passage, reads it in a particular way, and makes it serve a particular purpose within her argument. But it is also what the body does when it ingests food, extracts from it the nutrients it needs, and eliminates the rest; and it is what takes place when molecular bonds are broken and reconfigured in a chemical reaction. For Nietzsche, then, interpretation accounts for "all events in the organic world", and beyond. He goes on to remark that, in this broad sense, interpretation is the essence of "the will to power", and that will to power is the very principle of change in the world.[2] In this model, then, listening is interpretation, which is necessarily political insofar as it is involves a constant struggle and negotiation among entities.

But why return to Nietzsche for an analysis of listening—especially listening today in the age of big data and surveillance capitalism? I do so for two reasons: first, to remind us that our current situation is not as novel as we sometimes take it to be; and, second, to make a broader point about what listening is and what a politics of listening might be. Let me take up the second of these points. Nietzsche's polemically broad conception of interpretation contests the special status of human beings and of human interpretation, asserting that all entities (human, animal, vegetable, mineral, mechanical, etc) are engaged in this battle of interpretations. This is relevant to our consideration of both listening and politics. In the announcement for this symposium, the organisers quote a passage by sound artist Lawrence Abu Hamdan, who writes: "Listening is not a natural process inherent to our perception of the world but rather [is] constructed by the conditions of the spaces and times that engulf us."[3] Now, I am very fond of Abu Hamdan's work, which, I think, is smart, subtle, and richly manifests the role of sound in social struggles. But I want to contest a key presupposition in his claim about listening. Implicit in the passage is an opposition between "hearing" and "listening", the former conceived as merely natural, animal, and passive, the latter as properly cultural, human, and active.[4] This distinction is problematically humanist, taking human intentionality to be fundamentally different and distinct from the receptive capacities of other beings. And it is metaphysically problematic, insofar as it affirms age-old but dubious oppositions between nature and culture, sensation and thought, passivity and activity, instinct and reflection, the animal and the human, the material and the spiritual, the inanimate and the animate, and so on.

The distinction between hearing and listening is not only ontologically problematic; it also misleads us about the politics of

listening. If we take listening to be "socially constructed" rather than "natural", we project a second world of culture on top of nature or the real; this allows us to ignore Nietzsche's point that every entity in the world is fundamentally interpretive—that nature is already interpretive, and hence political, insofar as interpretation is "will to power". The notion of social construction and the elevation of listening above hearing places agency only at the level of the human and suggests that technologies of listening are inert and passive. Yet, as AJ Hudspeth nicely shows, the human apparatus of listening is far more passive and habitual than we take it to be, and mechanical *apparati* of listening are far more active and "interpretive" than we take them to be.[5] A fully materialist conception of listening would level the ontological field, rejecting the ancient metaphysical hierarchy that elevates the human above the animal, the inanimate, and the mechanical, and would reconceive listening in terms of capturing (and being captured by) flows of sound rather than in terms of some uniquely human intentionality. Indeed, it would turn the discussion away from human intentions and turn it toward the complex material conditions and *apparati* that determine what is captured, how, and why.

Let me bring this back to the discussion of listening in the age of surveillance. What Seeta Peña Gangadharan and Shoshana Zuboff call "surveillance capitalism" is what, 25 years earlier, Gilles Deleuze proposed to call "control society". In a brief but remarkably prescient text from 1990, Deleuze notes that we are moving from what his friend Michel Foucault called "disciplinary societies" toward a new organisation of power that Deleuze termed "societies of control".[6] The "disciplinary societies" that arose in the seventeenth and eighteenth centuries were fundamentally concerned with social regulation through the visual surveillance of bodies and operated through spaces of confinement such as the school, the army, the factory, the hospital, the asylum, and the prison.[7] But in the "societies of control" in which we now live, argued Deleuze, power is exercised differently. Instead of confining bodies to institutions, "control societies" are decentralised and flexible, involving "ultra-rapid forms of apparently free-floating control" that encourage the mobility of bodies while carefully tracking their movements, charting the nodal points in the networks through which they pass.[8] In short, control societies are post-Fordist societies characterised by precarious and immaterial labour, information, social media, e-commerce, data mining, and so forth. The form of surveillance that characterises societies of control is not the visual surveillance of bodies but the statistical accumulation, linking, and parsing of data that transforms individuals into "dividuals", identities reduced to packets of information that generate social, economic, and military profiles.

Deleuze's notion of "control societies" derives from the writer and sonic experimentalist William S Burroughs, who, in the 1960s and 1970s, developed a conception of control that seemed paranoid at the time but has turned out to be strikingly accurate.[9] Alongside this notion of control, Burroughs developed a rigorous conception of listening as a political practice. Instead of asserting the value of human intentionality and insisting that we wrest control from machines, Burroughs argues that everything is fundamentally a machine. The mind or the brain, for example, is a recording apparatus—a "soft machine", as Burroughs called it: an archive of received opinion, prejudice, ideology, gossip, instinct, physical habit, conceptual furrows cut by grammar and logic, and mental patterns of association. This is made apparent to us by another machine, the tape recorder. In an experimental text titled "The Invisible Generation", Burroughs writes:

> [A] tape recorder is an externalized section of the human nervous system...

you can find out more about the nervous system and gain more control over your reactions by using the tape recorder than you could find out sitting twenty years in the lotus posture or wasting your time on the analytic couch... listen to your present time tapes and you will begin to see who you are and what you are doing here... study your associational patterns and find out what cases in what pre-recordings for playback.[10]

We must become attentive to the mechanisms of control, Burroughs insists; and this requires that we make manifest its codes, defaults, and memes. For Burroughs, this was primarily a practice of listening, of careful attention to the word as it is registered and looped back through "pre-recordings" that infect and replicate in our cognition and imagination in the form of speech patterns, cognitive habits, and earworms. More broadly, Deleuze suggests, it means becoming attentive to the ways that our bodies, capacities, attentions, and desires are solicited, routed, and routinised. Awareness of these control mechanisms enables new forms of resistance. To this end, Burroughs devised a host of procedures to manipulate and alter audio recordings as a way to scramble the viral code, "isolate and cut association lines of the control machine", and generate liberatory juxtapositions, texts, sounds, and ideas.[11]

In this Burroughsian, Deleuzian, and Nietzschean sense, then, the politics of listening is a battle of interpretations, an *agon*. Within this agonistic space, everything listens, everything interprets. And in this battle, our machines are neither simply our tools nor entities that dominate us but participants in this struggle that have their own means and ways of listening and interpreting. If we reconceive ourselves as recording machines, as tape recorders, we might become more attentive to the mechanisms of control that we are and to experiment with ways to subvert or resist this control in alliance with machines and other non-human entities that exist with us on the same ontological plane.

1. Nietzsche, Friedrich, *On the Genealogy of Morals*, Walter Kaufmann and RJ Hollingdale trans, New York: Vintage, 1989, 3: 24, p 151.
2. Nietzsche, *On the Genealogy of Morals*, 2:12, p 77. For a more detailed discussion of this expanded conception of interpretation as will to power, see Cox, Christoph, *Nietzsche: Naturalism and Interpretation*, Berkeley: University of California Press, 1999, chapters 3 and 4.
3. Lawrence Abu Hamdan, notes on the project *Tape Echo*, 2013, http://lawrenceabuhamdan.com/#/tapeecho/, cited in http://www.veralistcenter.org/engage/event/1951/what-now-the-politics-of-listening/
4. For a text that develops this distinction, see Barthes, Roland, "Listening", *The Responsibility of Forms*, Richard Howard trans, New York: Hill and Wang, 1985, pp 245–260.
5. Hudspeth, AJ, "A Scientific Definition of Listening", paper presented at the 2015 symposium What Now? The Politics of Listening, Vera List Center for Art and Politics, The New School, New York City, 24 April, 2015.
6. Gilles Deleuze, "Postscript on Control Societies", *Negotiations: 1972-1990*, Martin Joughin trans, New York: Columbia University Press, 1995, pp 177–182. See also "Control and Becoming", a discussion between Deleuze and Antonio Negri from the same year, in the same volume. Deleuze first made the distinction between discipline and control two years earlier, in a 1988 text on Foucault called "What is a Dispositif?" in *Two Regimes of Madness: Texts and Interviews 1975–1995*, David Lapoujade ed, Ames Hodges and Mike Taormina trans, New York: Semiotext[e], 2006, pp 345–346.
7. See Foucault, Michel, *Discipline and Punish: The Birth of the Prison*, Alan Sheridan trans, New York: Vintage, 1977.
8. Deleuze, "Postscript on Control Societies", p 178.
9. This notion is developed in the cut-up novels *The Soft Machine*, 1961/1968, *The Ticket that Exploded*, 1962/1967, and *Nova Express*, 1964, and developed in essays such as "The Invisible Generation", 1966, "Electronic Revolution", 1970–1971, and "The Limits of Control", 1975, all reprinted in *Word Virus: The William S. Burroughs Reader*, James Grauerholz and Ira Silverberg eds, New York: Grove Press, 1998. See also Burroughs, William S, and Bryon Gysin, *The Third Mind,* New York: Viking, 1978.
10. Burroughs, William S, "The Invisible Generation", p 222.
11. Burroughs, "The Invisible Generation", p 224. Many of these experiments can be found on *The Best of William Burroughs* from Giorno Poetry Systems, Mouth Almighty Records, 1998, Disc 4, and *Break Through in Grey Room*, Sub Rosa SR08, 2001.

Tacet, or the Cochlear Vertigo:
Towards the Limits of Hearing

Council

Grégory Castéra
and Sandra Terdjman

[Towards The Limits Of Hearing]
Tacet, or the Cochlear Vertigo—a project initiated in 2013—arose out of our encounter and experience with a school for deaf and hard of hearing children in Sharjah (United Arab Emirates). The project aims to offer new dimensions to listening by exploring sound perception among profoundly deaf persons.[1]

"The essay", an ongoing written element of this project, traces the history of our research through written accounts and interviews, reproductions of texts and commissions, as well as artworks designed for online exhibition. The essay will be regularly updated and expanded, concluding with an exhibition scheduled for 2016. Over the course of our research to date two artistic productions were developed: a choreographic work by Noé Soulier and Jeffrey Mansfield, and a sound installation by Tarek Atoui. The Research group for this inquiry is Bassem Abdel Ghaffar, Tarek Atoui, Hansel Bauman, Desiree Heiss, Wendy Jacob, Jeffrey Mansfield, Noé Soulier, and Inigo Wilkins.

[Many Rounds To Reach The Sounds That
Are Listened To But Not Perceived]

> The cochlea is the auditory portion of the inner ear. It is a spiral-shaped cavity in the bony labyrinth, in humans making 2.5 turns around its axis, the modiolus. A core component of the cochlea is the organ of Corti, the sensory organ of hearing, which is distributed along the partition separating fluid chambers in the coiled tapered tube of the cochlea. The name is derived from the Latin for snail shell, which in turn is from the Greek κοχλίας kokhlias (snail, screw), from κόχλος kokhlos (spiral shell) in reference to its coiled shape; the cochlea is coiled in mammals with the exception of monotremes.[2]

[From Hearing To Listening]
The hearing range of the human ear is generally situated between 20 Hz to 20,000 Hz, while, for instance, dogs, cats and dolphins can perceive ultrasounds up to 45,000, 65,000 and 500,000 Hz respectively. Among ideally-abled humans, this function is principally fulfilled by the cochlea. Deafness is described as "total" when the cochlea perceives no sound at all, and as "profound" when, for example, the cochlea only picks up the sound of a road drill; deafness is termed "severe" when the cochlea only perceives the sound of a noisy street, and, correspondingly, "moderate" for a loud conversation, and "mild" for an average conversation.[3]

5 per cent of the world population—ie, 328 million adults (and about half of the over 65s population) and 32 million children—are affected by at least mild deafness.[4] About 200,000 people in France are profoundly deaf, and 800,000 people are severely to profoundly deaf in the UK (there are no available global statistics).

The deaf population, which was for a long time ostracised, has developed a particular culture centred around sign language, in

reaction to the predominance of orality in communication (even though sign language, and, as demonstrated more recently, vibrations, are among the easiest to learn, most effective and precise forms of communication we have). Although now viewed in a favourable light, the way these two forms of deaf perception engage the body are at odds with most social conventions for they involve two taboos: gesticulation and enjoyment.

Sound as perceived by profoundly deaf persons is not concentrated in the cochlear spiral. Instead, its vibrations are perceived throughout the body. The same part of the brain, the auditory cortex, is activated when we listen and when we perceive vibrations. Deaf persons also develop myriad techniques to form speculations on a sound environment that may be inaccessible to them through hearing but can be deduced via visual signs and knowledge of context. This extension of the hearing capacity, which links hearing to touch and sight, allows us to problematise the modern, mentalist conception of hearing, restricted and reduced to the head, which perpetuates the Aristotelian mind-body dichotomy.

When described from a deaf-world perspective, listening is the ability to experience and anticipate sound through hearing, touch, and sight. Far from seeking to rework classic conceptions of listening, our research is grounded in a conception of listening as pertaining to a composition between various senses that make up an ecosystem—a perspective that envisions continuities between physically perceived sound and its virtual forms, new articulations between the public and private sphere and new forms of communication. This description can provide the basis on which the traditionally separate deaf and hearing institutions can configure ways of connecting (at least partially).[5] In other words, our research explores the extent to which a sound can be perceived and the political representations potentially opened up by this diversity of listening modes.

[Method]

> I grant that this title is applicable equally to the large
> number of those who speak without understanding,
> and the small number of those who understand without
> speaking, and to the very small number of those who
> speak and understand, and for whose use my letter is
> solely intended.[6]

As the Denis Diderot quotation above explains, our research has not been conducted for nor exclusively by members of the deaf community. We believe that community empowerment develops by experimenting with the interplay between the community's own political representation and that of outside actors nonetheless sufficiently tied to the community to be able to speak on its behalf. If these ties are strong enough they enable new communities to emerge while at the same time reinforcing the original community. The project grew out of our encounters and experiences with various organisations and educational institutions devoted to the deaf community, and it began to take shape around our observations concerning the role of sound in this interplay of political representations.

Often out of ignorance, but sometimes purposefully in order to reinforce the image of an isolated community, the world of deafness tends to be associated with silence. The title of our inquiry, "Tacet" (a reference to John Cage's works on silence), presents silence as a disposition allowing access to the lived but unperceived dimensions of sound.

Deaf artists often engage with sound through synaesthetic operations that make sound perceptible through visual translation. The essay will present a selection of these works that are part of an international movement employing highly sophisticated practices but whose history has yet to be written. Among the hearing population, two caricatural extremes tend to prevail: certain scientists apprehend deafness as a disability that must be compensated for through technology; the polar opposite position held by certain artists regards deafness as the development of abilities that give access to extraordinary dimensions of perception. This tendency links up with certain positions held by members of the deaf community who defend a form of communication that goes beyond oral language.

The focus of our research was gradually defined by these various approaches to sound. We conducted our inquiry from February 2012 to April 2014. The various stages of research ultimately brought together researchers hailing from areas as diverse as sound studies, deaf studies, sound art, neurology, architecture, translation, design, literature, music, sound engineering, and the visual arts—all involved, to varying degrees, in one or more of the research phases.

Starting from a specific experience in a particular context, our field of research has gradually broadened, seeking to reach dimensions not mutually commensurable, whose contradiction might prove fruitful and ultimately foster a new description of listening (at least the hallucination of the different dimensions of the issue). In this way, the title of our study, "the Cochlear Vertigo", points both to the spiral-shaped portion of the auditory system and to the winding path of our research. The piece by Aurélien Gamboni and Sandrine Teixido, based on Edgar Allan Poe's short stories *A Descent into the Maelström*, 1841, also uses this motif to account for the modes of attention required to engage with complexity.[7] Artist Gabriel Lester has also revealed that he uses this strategy to better apprehend a context when he embarks on a new project.

We established a collective whose structure is specific to the research undertaken and goes against the grain of several conventional ideas concerning collaboration. In this way, collaborators are not required to meet an equal level of involvement, nor does the collective impose an equal balance in its hybridisation of practices—principles often considered the only way to make a project truly collective and to represent the commons of a community in the making. Similarly, decisions regarding the structure of our inquiries are not subjected to the logistics of collective decision-making as all major choices regarding procedures and project orientation are ultimately made by Council. Finally, the structure of the collective is such that not every action carried out, however technical, is necessarily apprehended

Documentation of a workshop led by
Wendy Jacob in collaboration with
Hasan Hujairi, 2013.

What Now?

as an opportunity for building the collective. In this way, we have employed various forms of delegation in the course of our research.

[The Structure Of The Essay]
The essay establishes a picture of the artistic and scientific treatment of sound perception among the deaf community (through reproductions of texts, the commissioning and presentation of artworks) and documents various experimentations conducted over the course of the inquiry. It is structured around six sections:

The INTRODUCTION presents the stakes of the inquiry and its process, through narrative, data visualisation, and written fieldwork accounts.

TOUCH unfolds different dimensions of our relationship to touch: enjoyment, raw perception, and the link between touch and listening.

INDIRECT PERCEPTIONS explores the techniques employed for perceiving the indirect signs of a sonic activity and the consequences of the continuity between perceptions and virtualities in developing nuanced modes of attention.

GRAMMARS explores sound expression through gesture in sign language, linguistics, and choreography.

EXTENSIONS returns to the debate surrounding cochlear implants and broadens it by attending to the historical relationships between the deaf community and technology.

REPRESENTATIONS investigates the issues and implications of an artistic and political representation of disability. In addition to this, two artistic productions emerged from our research: a choreography by Noé Soulier and Jeffrey Mansfield, and a sound installation by Tarek Atoui (both to be presented in 2016).

[Council]
A council practices the art of assembling people in order to decide how to act for themselves and for those they represent. Councils are common to different cultures around the world, and are practiced at different levels of society: the family, trade unions, states, militant groups, businesses, and religious communities. Shared by all, council is an activity from which new forms of political representation may emerge.

Founded in 2013 by Grégory Castéra and Sandra Terdjman, and animated by a network linked to the arts, science, and social engagement, Council develops an artistic institution born out of the art of council. Today, Council brings together an artistic research laboratory (the inquiries), a programme for the production of artworks, and a fellowship.

Introducing the arts in domains that do not fully recognise its legitimacy, merging the arts with sciences and civil society, and

staging new forms of council: Council tests the hypothesis that the evolution of political representation implicates aesthetic operations.

Council acts in the long term and on an international scale, modulating its structure according to the necessities of its activity. In accordance with these conditions, Council seeks to observe situations where human nature is re-examined, and to experiment with radical alterity: "the way I do not understand the other is different from the way he does not understand me".

1. To read more about this Inquiry, please see the Council website: http://www.houseofcouncil.org/en/inquiries/30_tacet_or_the_cochlear_vertigo
2. Definition sourced from Wikipedia.
3. The BIAP—International Bureau for Audio Phonology, http://www.biap.org/
4. World Health Organization. "WHO global estimates on prevalence of hearing loss", 2012, http://www.who.int/pbd/deafness/WHO_GE_HL.pdf?ua=1
5. We use the term "institution" in a Durkheimian sense—an already existing or pre-conceived mental or cognitive representation.
6. Diderot, Denis, *Letter on the Deaf and the Dumb for the Use of those who Hear and Speak*, 1751.
7. The drawing by Aurélien Gamboni and Sandrine Teixido depicts the sailor's changing mental state, in relation to his perception of his position in the whirlpool.

Fact

Fiction

and the In-between

What is the Shape and Feel of the In-between?

Lauren van Haaften-Schick

What lies between fact and fiction? Before we ask this question we should consider the premise it assumes: that fact and fiction exist in a binary relationship, with each standing at a distinguishable pole separated by an undefined in-between acting as both conduit and barrier. This image of fact and fiction as situated in lateral opposition to one another is a kind of fictive image of its own, an invented constraint imposed for the sheer purpose of advancing the utilitarian differential between the facticity of stated truths, and the abstraction of invented fictions. Yet history, culture, and the science of human memory tell us that this separation is never quite so clean, and that the information deemed as fact and the narratives invited as fictions have a tendency to swap positions or slip into each other's roles. The difficulty in considering the question of what lies between fact and fiction is not in simply answering the initial inquiry—the real trouble resides in the assumptions made in asking the question.

If the space of this mythical "in-between" is truly impossible to define within the parameters of our initial premise, what other models can we consider in envisioning a more accurate shape and feel of the fact-fiction relationship, and that which rests in-between? Rather than reinforcing the difference between each side of this divide, we should instead consider that there does not exist a linear, static middle separating these two conditions. Instead, we might find a more familiar, practical, and humanistic model in embracing the fluidity between the two if we envision not a separation imposed by an oppositional state, but a symbiotic and cyclical relation churned by the necessity of the law, the psyche, and our physicality. We might sway between claiming that a statement is either fiction or fact with the understanding that both statuses propose different categories of truths, so that the dialogue and negotiation that occurs in forming either distinction is vital to one another's making.

In codified law and judicial analyses, legal fictions are understood to be a narrative leap above and beyond presented facts, necessary for advancing a puzzling judicial inquiry, or for expanding the limits of what is possible to conclude under legal rubric. According to legal scholar Lon Fuller, a fiction clearly occurs when the author of the statement either "positively disbelieves it or is partially aware of its untruth or inadequacy", yet employs it nonetheless in the process of locating a negotiated, realistic truth.[1] If a thought lacks a physical counterpart, or cannot be substantiated by empirical fact, we consider that thought to be a fiction. What effect does this forcing of factitious reasoning have upon legal determination? It compels us to employ fiction as a conceptual stand-in for material fact.

One functional breed of the legal fiction can be referred to as presumption or implication, whereby culturally and experientially perceived logical reasoning can fill the remaining gaps in an incomplete suite of evidence. The necessity for presumption within judicial consideration is one example of a legal fiction that serves to constrict an array of unknown factors to a reduced set of plausible facts. Fuller uses the example of the time between the disappearance of a person and their recategorisation as dead to explain one function of presumption in legal and logical consideration. When a person has disappeared and has been unheard of for seven years they are usually dead. Why seven years? According to Fuller, the best explanation we can offer is that this is a presumption warranted by experience revealing this to be the typical outcome.[2] Here, that which is expected or probable can be employed in informing or

substituting for an unknown fact. Clearly, without material proof, we cannot agree to say that this presumption of death is entirely "true", nor does this type of presumption present a case that is entirely non-fictitious.[3] Instead, the truthful conclusion that we and our judiciary must accept after this determined period of seven years of an individual's absence is but a logical tool, and a fiction necessary for advancing the narrative of a person's disappearance towards an acceptable likely truth. Here we can see that such legal fictions have the capacity to operate in service of the emotional and psychological, as in the case of the disappearance of a spouse, and the point of closure that one is tacitly encouraged (or forced) to come to once the seven-year mark has passed. Such presumptions also fulfil the role of a social standard, or symbolically codify, in a sense, the need for agreed-upon minimums of what can be considered typical, shared experiential knowledge, and a standard of social reliance.

In other instances a fiction might be intended to escape the existing, specific rule of law, perhaps with the goal of changing an existing law, or of challenging the practicality of codified law. Such fictions might be considered as playful leaps of reason designed to introduce an "as-if" hypothetical real, and must be employed with the reminder of their actual and known un-provability. Here is where moral code may enter a judicial opinion, and where a fiction is utilised as a substitute for what could be, and in more extreme instances, what should be. Fuller provides the following example: Roman law stated that "The testament is the last will of a Roman citizen; whoever lacks this status at the time of his death can leave no valid testament." Under this code the judiciary is presented with a dilemma in the case of Roman citizens who died while in captivity of the enemy as slaves, as Romans in this predicament would lose their citizenship. To cope with this odd injustice under the law, the principle of *fictio legis* Corneliae was employed to formulate a statute that would allow for the deceased to retain their rights in death as if they had died at the moment of capture.[4] Here the legal fiction operates to remedy a

clearly inadequate statute concerning the rights of certain deceased citizens, and yet in doing so alters a known and accepted truthful and tragic personal history of the deceased individual in question, as if to rewrite their past with a narrative more closely reflective of what should have been. Thus we can observe that it is not only the law that is subject to emotion and moral imposition, but more so, that the very stability of historical narratives, and the archives or factual records upon which they are built are equally prone to fictional influence and revision.

That we might understand a "fiction" as occupying a position above, or as capable of, influencing the supposedly ever-concrete and immovable institution of legal facticity may seem an absurdist proposition. Yet the prevalence and necessity of such gestures reveals not only the fallibility of legal code, but that the law is the product of culture, and the human—and is therefore comprised of material truths, pure convenient lies, wavering statements, and imperfect memory. As such, we can observe that the narratives that comprise legal recorded fact and its archive of "true" historical narratives have never been static, have never been neutral, have never been inhuman. As such, we might identify the breathing force fuelling the cyclical motion between fact and fiction as the physiology of the law and the archive, where each institution can be imagined as a physical body in motion whose organs are comprised of the witnesses, storytellers, judiciaries, cataloguers, and collectors who compose and define it, along with the expected imperfections and complications introduced by the limitations of the human.

It is no coincidence then that Fuller's explication of legal fictions includes a discussion of German philosopher Hans Vaihinger's *Die Philosophie des Als Ob (The Philosophy of As-If)*, a systematic study of the influence of fiction in all realms of human intellectual activity, which includes an extensive exploration of the physiology of human memory and thought and the role of these biological operations

in the determination of falsity. As Vaihinger observed, the mind is not merely receptive, it is appropriative and elaborative, so our minds are not "mere passive reflectors of the external world; they are instruments for enabling us to deal with that world". As Fuller asks, is it any wonder then that our minds would alter reality?

This operative alteration is most evident in the physiological processing of sound. Once sound waves meet our inner ear they undergo a multi-tiered process of absorption, analysis, synthesis, and are possibly followed by re-presentation in an altered form. The shape and structure of each individual's inner ear is full of variance, enough that we might say that no two people ever hear precisely the same sound. Once absorbed into the body and sent to be processed by the brain, the reception and synthesis of sound undergoes an equally physiological and psychological process of synthesis and storage, and is always remembered—consciously or not—as bundled with a host of associations informed by past and present experience. The human ear even emits its own tones in a kind of otoacoustic call-and-response system with the audible environment, including others' ears.[5] Often, that which is casually perceived either auditorily or visually is only logged in the brain once an additional event already deemed to be worthy of remembering is encountered in tandem. This phenomenon poses a clear difficulty to the courts' reliance on witness testimony, which is often built on fictive recollection peppered with details here and there that may have struck a witness as significant for some unknown subjective reason.[6] Once recalled, a sound received and the memory of its experience and reception will never mirror precisely the moment of its transmission. Instead, the shape and feel of a remembered truth, a remembered fact, and the recording and future emission of it will always be subject to the alterations that are a by-product of its human processing.

In the most abstract sense, this observation shakes the very reliance that there is an objectively definable shared experience, or

that we can rely on expressed and recorded historical testimony and other oral records as neutral fact. Yet as Fuller asks, "Is it not clear, on reflection, that we have been determining 'truth' or 'falsity' by the inquiry: Has the idea in question a counter-part in the world of reality external to us?.... This lack of a physical counterpart for our intellectual processes is the thing that has led us to call our ideas 'false'."[7] If the alteration that reality undergoes in our minds is called "falsification", he continues, it is because we have been proceeding upon an erroneous theory of truth. This for Fuller and Vaihinger is the most troubling premise from which we must advance our understanding of fact versus fiction.[8] Rather than dismiss the process of elaboration and alteration as a sign of the weakness of human physiology and intellect, Fuller argues, we should instead recognise how this process demonstrates the vigour and additive capacity of our minds, revealing that the "truth" is forever coupled with, and coloured by, the trail of fictions that come before and after its identification. Applying this understanding of expected alteration, we can extend this conclusion further to demonstrate that law itself is a fiction.[9]

Despite the acknowledged instability of the truthfulness of codified law and the accuracy of the narratives contained within the historical archive, there is a reason why we have looked to the archive and the law as authoritative institutional forces. In the process of reaching a conclusion, and of advancing the legal or historical framework that can be relied upon by society as "true" the lines must at some point be drawn between that which is true and that which is false, and the minima facts must be divided from the infinitely additive fictions. Fuller further cites Vaihinger in emphasising that in the process of employing an unknown variable or fiction to advance a system of logic, and to eventually reach a "final reckoning", the fiction must at one point be removed from the equation. As the legal scholar writes, "these constructs must be used as instruments of thought only; we must treat them as servants

to be discharged as soon as they have fulfilled their functions".[10] Highlighted here is the importance of the decisive narrative, which while it may always be vulnerable to challenge and future revision, must at one point be presented as both factual and true. Only then can one know where and how to apply a layer of fiction, and thus locate the in-between.[11]

1. Fuller, Lon L, *Legal Fictions*, Stanford, CA: Stanford University Press, 1967, p 8.
2. Fuller, *Legal Fictions*, p 46.
3. Fuller, *Legal Fictions*, p 34.
4. Fuller, *Legal Fictions*, p 54; Buckland, WW, *The Roman Law of Slavery: The Condition of the Slave in Private Law from Augustus to Justinian*, New York: AMS Press, 1969, p 300.
5. See generally: Hudspeth, AJ, "The Energetic Ear", *Daedalus* 144, no 1, 1 January, 2015, pp 42–52.
6. For example: One witness happened to admire a perpetrator's shirt just before viewing them committing a crime; another witness overhears a call for help and the voice sounds just like their daughter; another witness just across the street thought he heard two teenagers playing.
7. Hudspeth, "The Energetic Ear", pp 42–52.
8. This coupling fact/fiction and truth/falsity reveals another disturbing linguistic assumption: that these binaries are interchangeable, thus implying an equivalence between fact and truth, and fiction and falsity, which has been demonstrated to be an inaccurate parallel at best.
9. In conversation with Sergio Muñoz Sarmiento, July 2015.
10. Fuller, *Legal Fictions*, p 121.
11. In conversation with Naeem Mohaiemen, April 2015.

Aural Contract: Towards a Politics of Listening

Lawrence Abu Hamdan

"It has often been said that speech is what makes us political animals and as such, how our speech is being heard today and how the law conducts its hearing, is a fundamental question in understanding our contemporary political moment. For the past year, I have been mainly dedicated to understanding the role of the voice in law, and the changing nature of testimony in the face of new regimes of border control, algorithmic technologies, medical sciences and methodologies of eavesdropping. It occurred to me that in times past, when we swore to tell "the truth, the whole truth and nothing but the truth" in a court of law, we would undergo a transformation. Once those words were uttered in that space we would inaugurate new conditions of listening and our speech would transmute from normal conversation to liable testimony.

Yet now, we are in an age when we are sworn in the moment we accept the terms and conditions of a particular communications software or mobile phone network. These vast apparatuses for listening, constantly filtering our communications for incriminating words, mean that all speech we utter is liable, wherever we are. We can no longer depend on traditional contexts—such as the police interrogation room, or the witness stand—in terms of where and when our voices are heard by the law. Our speech is legally accountable in all sites and across international jurisdictions. So how did we get here?

[1984: The Birth of Forensic Listening]

My argument is that this era, this "contemporary politics of listening", can be traced back to no other than 1984, and here I mean the year, not the book. In 1984 something happened in Britain, which then started going on all over the world, and this was a radical form of listening. This "sonic avant-garde" as I call it, was not attached to a cultural project or a musical endeavour—it actually owed its origins to the passing of a piece of legislation called the Police and Criminal Evidence Act. This was the moment when all police interviews became audio recorded. So, rather than you signing off on a summary that was written down by the police officer, from that moment onwards the whole voice was captured in the interview—not just what you said but also how you said it. It was a very important moment, because the Act was put in place to battle claims that police were falsifying testimonies, or that words were being put into people's mouths. And this verballing was going on to such an extent that they said, "Ok, we'll record everything", so they would have an accurate record of what was said.

In theory it sounds like a very good, transparent piece of law making. In fact, as a transparent piece of law making, it worked—but something unexpected also happened. It gave birth to a new era of investigation, which I call "forensic listening", but at the time was called "forensic phonetics" or "forensic linguistics". Essentially, the police realised that they had accumulated the world's largest audio archive, and that they were accumulating it very quickly as every police interview across the country was being audio recorded on cassette tapes. This huge archive of interviews became a resource for linguists, as all the regional accents were captured in one place. This also led to an interest in other kinds of

analysis, such as the "eugenics of the voice" and the latent criminality that could be embedded within it.

In this way the Police and Criminal Evidence Act rapidly increased the application of forensic listening in legal investigations, and widened the attention of the law to not only include the voice, but also other sounds that constitute a sonic environment. As listeners increased their expertise through access to this archive, the police also started to record all emergency phone calls in around 1997 as they realised that the emergency itself was often captured on the call. In retrospect, it was not so much the voice of the caller that was of interest to the police, but rather the event they may inadvertently be recording. The same linguists were then called upon by the police to identify sounds in the background, such as gun shots. Suddenly, people with expertise in phonation and articulation of the voice started to be tasked with identifying other sounds, for example, zooming into the background in order to identify the architectural space within which a call was made. So this piece of legislation enabled a complete spectrum of sonic frequencies to take the witness stand and testify, hence this law not only facilitated the birth of forensic listening, but also the death of background noise, and incidental and ambient sound as we might have known it.

One of the very few linguists practicing this rare strand of linguistics when the government passed this law was Peter French—who has now worked on over 5,000 cases since 1984, including the recent Trayvon Martin case. In that instance, he had to determine whether screams on an emergency phone call were those of Trayvon Martin or George Zimmerman, essentially helping to establish whether or not this was a case of self-defence. Such a case highlights a fundamental point, in that the person who may or may not have screamed is actually in that room, so their testimony about their own voice is separated from them in such cases. French has now worked on over 5,000 cases where the voice has played a central role in someone's culpability or identity, and he told me that in relation to the passing of this law, whereas up to that point they had only a trickle of work coming in, it was as if there had been a thunderstorm and it had started raining cassette tapes.

In my interview with him, French also told me that he and a colleague had recently spent three working days listening to one word from a police interview tape. This is why I began by saying that this is a radical form of listening because, for me, three working days on one word is beyond what even Terry Riley was doing in the 1970s and beyond anything I thought was avant-garde in terms of sound until that point. Statements like this exemplify French's radical approach to listening, and much as we may find French's radical practice of listening alarming, it is in its essence inspiring, and unlike many sound theorists who focus on sound's ephemeral or immaterial qualities, French's approach is markedly material; his formulation renders sound dissectible, replicable, physical, and corporeal. This radical approach to sound is possible because of the forensic intensity with which French has trained himself to listen.

This process allows the audio object to reveal a large amount of information as to its production and its form: the space in which it was recorded; the machine it was recorded on; the geographical origin of the accent; and the age, health, and ethnicity of a voice. If we imagine sound

as immaterial, ephemeral, and intangible, we run the risk of extracting it from the world in which it participates—and of essentialising sound and treating listening as a natural and given phenomenon that is trans-historical and apolitical. While the books in my university library were telling me about sound as an immaterial phenomenon, it was the work of Peter French that taught me that listening is a political practice, even though his politics are almost completely opposite to mine. And as such, it is important to preface the projects that I am talking about by saying that forensic listening is not so much a research interest of mine, but rather a kind of political and theoretical way of intervening in the politics of the world that surrounds me.

[Case One: Speaker Systems]
Tinnitus, that constant mosquito-like ringing in the ears has become a common ailment for those who cut through the dense sonic-topography of Cairo on a daily basis. Even on Fridays when the city's tools are down, the sound-emitting urbanity persists. In the afternoon, the thousands of mosques that fill the city each pump out their Friday sermon onto the streets, broadcasting the interior voice of the mosque into its surrounding neighbourhood with the use of omnipotent loudspeakers. The "topic of the day" that each Sheikh from each mosque discerns as notable for those ears who populate his jurisdiction to hear, adds to the already high volume of noise. The streets become awash with thousands of amplified preachings that intend to function as a "reset button" for the listener: an ethical enema for the ear canals, washing out the blasphemous cacophonies and audio abuse that has built up in their auditory organs throughout the week before.

 Yet sometimes these amplified clusters of ethics are themselves painful to hear as the harsh voice of an unqualified Sheikh blasts with the sharp frequency of the speaker-horn. Chinese-made, Egyptian-assembled speakers seem to singularly fuel the loudspeaker libertarianism that is rife throughout Cairo. And so pervasive in daily life are these loudspeakers that the issue of hearing damage and noise pollution was immediately accepted as a topic for a Friday sermon when I suggested the idea to two Cairene Sheikhs. Despite laws that the military government established to monotonise the delivery of sermons by enforcing Sheikhs to only give speeches according to the weekly government sanctioned topic, our Sheikhs remained even more determined to have the issue of noise heard—not only by the congregation inside the mosque but also by passers-by in the street. The military crackdown on the amplified voices in the city is done in the name of policing noise and the lawless terrain of the loudspeaker, yet it is in fact a means to direct the flow of voices away from espousing anything against the government.

 These policies propose to protect the tinnitus-ridden hearing of the Cairenes, yet as an act of censorship it threatens to deafen them even more. On the day the Sheikhs delivered their sermons on noise pollution and hearing damage, as far as the ear could hear, all the mosques in the surrounding area were explaining Muhammad's Ascension to Heaven, the government dictated topic of that week.

 One can measure the distinction between the way politics is conducted in authoritarian regimes like that of Abdel Fattah al-Sisi in Egypt, and liberal

democracies, by a simple diagram of listening. In authoritarian regimes you can't say anything because everything you say is being listened to. Conversely, in liberal democracies, you can say what you want because nobody is listening. This image shows the UNHRC (United Nations Human Rights Council) and it has a very interesting setup. There is no amplified voice in the room, so what looks like a classic oratorical space inherited from Greek times is actually quite distinct from it in that the speaker is not broadcast aloud in this room. Here we have moved from the excess of amplified voice in my first example to a complete lack of it. Actually the voice of each speaker is heard by means of a single earpiece that is on each table, otherwise you would not be able to hear them, but it is important to note that as a single earpiece, it leaves the other ear exposed to the sounds in the room.

This situation moves away from an oratorical space in its classical sense and becomes more like shouting in a busy office. Essentially, it shifts from thinking about listening to just the pure act of recording one's human rights violation. Rather than going into a space and actually listening to what people say, you are just preparing for the moment when you will go up and record your own violation in the room—people are basically preparing papers and getting ready to give their speech. This rather violent intervention into the oratorical space produces occurrences of "mis-hearing" in moments where supposedly the most vital of voices are to be amplified. This attack on listening, this forced desensitisation to sounds, makes me wonder what kind of issues are slipping through the net, and what kind of stories slip off into inaudibility as the ear piece itself loosens its grip on the ears of its auditor. With this lacklustre listening, what kind of violence is going on unnoticed right under the ears of these representatives?

[Case Two: Suppressing Sounds]
In a different case, I conducted an audio forensic analysis for the Forensic Architecture research project and Defence for Children International, Palestine. On Nakba day, 15 May 2014, 17-year-old Nadeem Nawara and 16-year-old Mohammad Abu Daher were fatally shot while security and TV film cameras were rolling, in the town of Beitunia, near Ramallah. The videos showed that the two Palestinian teens were shot while walking unarmed and posing no threat. Despite this footage, the Nakba day massacre was denied, just like the Nakba of 1948 it was commemorating. This is how it was denied: "The preliminary IDF inquiry indicates that no live fire was shot at all on Thursday during the riots in Beitunia and we have to determine the cause of this result." The claim was that rubber bullets, rather than live ammunition, had been used but we know that both people died from live ammunition fire. The proof was deemed to be clearly visible—all the Israeli soldiers were firing with rubber bullet extenders mounted on the ends of their guns, so therefore they were firing rubber bullets. But what happens when we actually *listen* to this event rather than look at it?

CNN was filming and caught the two people who actually shot Nadeem Nawara. Two shots can be clearly isolated. In the case of the first shot, if you synchronise the images you can see that this was the exact moment when Nadeem Nawara was killed, so there is something that can be presumed about the nature of this gunfire. Then there was another shot, and this was

actually the one that killed him. What happened in the second shot is actually quite interesting. When you match the position of the two photographers, you see that there is a rubber bullet firing through the air. Live ammunition cannot be caught by camera as it moves too quickly, but a rubber bullet can be, and that is exactly what we have shown here.

Because I have done all this research into forensic linguistics, in some respects the charity that I was working with (Defence for Children International) had misunderstood what I do, and thought that I was a forensic audiologist, when in fact I am an artist. When they asked me if I could tell the difference, I couldn't actually do so on hearing it for the first time. What I then did was produce spectrograms, as it is much easier to compare colours—the spectrum of colour frequencies—than sound, and this revealed a distinction between the two shots. The second shot, the rubber bullet fire, is much higher in lower frequencies whereas the live ammunition fire, or what we presume is the fatal shot that killed Nadeem Nawara, is much higher in higher frequencies.

Unlike the killing of Nadeem Nawara, at the moment Abu Daher was shot, the camera was pointing away from both the shooter and the victim. We only have the sound of the shot that killed him clearly documented. With regard to audio forensics, the investigations into these two killings are interdependent; the sonic evidence of one death is corroborated by the other. When we look at these two cases together, a pattern emerges which points to the fact that not one, but two teenagers were killed as a result of Israeli security personnel masking the firing of live ammunition through a rubber coated bullet extension. It is important to say that it is actually neither the sound of live ammunition nor the sound of a rubber bullet that we were after, but rather the sound of the confluence of the two: the sound of live ammunition fired through a rubber bullet extender.

In the killing of Mohammad Abu Daher, five shots were recorded by the Palestinian news network that was filming. They sounded very similar to me the first time I listened, but more is revealed if we look at the spectrogram for the shots. The first shot is the one that killed Mohammad Abu Daher and the exact same pattern emerges from the CNN material of Nadeem Nawara: the low frequencies in all the non-lethal shots that were fired, and the very distinct sonic behaviour of the lethal shot. The rubber bullet extension, to a much lesser extent, has a similar effect on gunfire sound as a silencer. A silencer is designed to cloak and disguise the sound of live ammunition in order to not alert people in the vicinity to the sound of live gunfire. The rubber bullet extension also suppresses the sound of live ammunition, and to a lesser extent than a silencer, this extension can be used to disguise the presence of live fire. It becomes incredibly important to identify this sound of live ammunition fired through a rubber bullet adapter. It is a sound that needs to enter our acoustic consciousness, as it is the sound where the tools of institutionalised violence cross the threshold into acts of wanton bloodshed and murder. This is not a case of saying that rubber bullets are good and live ammunition is bad—but rather that the legitimisation of firing rubber bullets is exactly what allows somebody to sneak in a live round now and again.

Another interesting thing happens when we look at this material. The crowd reacted extremely differently to the lethal shot that killed Mohammad

Abu Daher—they hit the ground and ran, whereas in the other cases they ducked for a moment and then continued to throw stones. This tells us that the real expert listeners are the people who are continually exposed to this very finite sound. There is a very small distinction between rubber bullets and live ammunition fired through a rubber bullet extension. The sound that we struggle to hear in this room is actually easy to hear for those who are continually exposed to it and whose survival depends on it. Unlike Nadeem Nawara, Mohammad Abu Daher was buried according to Islamic law on the same day he was killed. This meant that his body could not be subjected to a post mortem examination. The human rights group Defence for Children International found this burial and refusal to subject the body to autopsy as a hindrance to their investigation (the human rights organisation sees these acts of immediate burial as uninformed and religiously conservative, rather than political). Yet immediate burial meant that the body never became subject to suspicion in how it was murdered. That Abu Daher was shot by the Israeli soldier in cold blood should be clear for all to see, even if there was no video. Here the right to burial exercised by the family of Abu Daher is a practice of the right to silence, a withdrawal from the traps of self-incrimination, a refusal to speak because the forums available for your speech are devised by the same authorities—and constituted by the same violence—that committed the crime in the first place.

The body is not a defendable object of legal scrutiny. In fact it is the specific character of the shot itself that is the crime. Sound in medicine has long been understood as the way for doctors to make a non-intrusive analysis of our bodies. Just like doctors have done, learning to listen and to use sound as a non-intrusive device shows its political potential as a medium of intervention. If we listen carefully to the shot that killed Abu Daher, we can hear that encoded into the sound of the gunfire is the totality of the crime itself. The buck stops with the blast. We do not need to disturb the body to know that Mohammad was killed by that border guard, but we need to be able to decode the sound to distil the intentionality behind his murder—the disguising of the use of live ammunition through a rubber bullet extender.

In this all-hearing and all-speaking era of forensic listening, such acts of silence—like the one practiced by Abu Daher's family—are becoming increasingly difficult to justify and more and more difficult to practice. If you look at WikiLeaks or the NSA, they believe that the secret is the biggest threat to democracy; in each case, from a system of total transparency to one of surveillance, we have the same logic that the only people to be feared and the only people who fear these systems, are those who have something to hide. Another alarming example of the diminishing acceptance of silence is President Obama's comment in 2009 on the then upcoming trials for those held in Guantanamo Bay: "The whole premise of Guantanamo promoted by Vice President Cheney was that, somehow, the American system of justice was not up to the task of dealing with these terrorists. I fundamentally disagree with that. Do these folks deserve Miranda rights (the right to silence)? Of course not." So we are moving increasingly towards a politics that upholds the freedom of speech but denies the right to remain silent.

[Case Three: The Freedom of Speech Itself]

My final case looks at something that is happening all over Europe—a series of accent tests that are conducted when asylum seekers are asked to give a recording of their voice to verify whether or not their accent matches the place they claim to come from. This is done by a Swedish company. Basically what they do, if they have a Somali case for example, is go to places like job centres, pick up a Somali guy there and ask him "where do you think this guy is from?" Then they put it in a kind of linguistic document and send it off to the courts in countries all over the world including northern Europe and Australia. There is a kind of violent synchronisation in which the voice is treated as a kind of birth certificate or a passport.

However, the voice is something very fluid, even "contagious", in that it can change depending on one's interlocutor. One clear example of this involved a man named Mohammad who was Palestinian, but because of the way he said the word "tomato", he was told he was in fact Syrian. This was in 2003 before Syria was actually a legitimate place from which asylum seekers were allowed to come. That syllable was the sound that provided the UK border agency with the apparent certainty of Mohammad's Syrian origin. It implied that this vowel, used in the word "tomato", was coterminous with Syria's borders. But locating this Syrian vowel in the speech of a Palestinian surely proves nothing more than the displacement of refugees themselves. In other words, the instability of an accent, its borrowed and hybridised phonetic form, is testament not to someone's origins but only to an unstable and migratory lifestyle—which is of course common in those fleeing from conflict and seeking asylum. Is it not more likely that a genuine asylum seeker's accent would be an irregular and itinerant concoction of voices, a biography of a journey, rather than an immediately distinguishable sound, a pure voice that avows its unshakable roots to a single place? The fact that this syllable designates citizenship above an identity card that contradicts it, forces us to rethink how borders are being made perceptible and how configurations of vowels and constants are made legally accountable.

There is a problem here, in that these people have the freedom of speech because that is an international human right, but they don't have the right to silence. If they choose to remain silent during these language interviews, they will be kicked out of the country because they have refused to cooperate. It is important to say that the right to silence is given to a citizen of a nation, but, in actual fact, a human does not have the right to silence, even though they may have the freedom of speech. So I would change the right to silence. In the UK, which is my context, it would go something like this: "You do not have to say anything. But it may harm your defence if you do not mention when questioned something that you later rely on in court. Anything you do say, including the way you say it, may be given in evidence against you."

The last point I would like to make is that in response to claims that this is an unjust way of analysing people based on where they are from, the border agency changed their procedure. In terms of the critique that the voice of the interviewer was actually affecting the way people spoke— which is a legitimate claim—the Government said, "Let's move this from being a dialogue between two people to being a monologue. So what we

want to do now is ask you to speak for 15 minutes on any subject, we don't care what you talk about, but then afterwards we will send the accent to be analysed." This kind of Beckettian move is very insidious, because it reveals that the freedom of speech has reached its nightmare conclusion: you can say whatever you want, no one gives a shit so you just keep talking. This is exactly the kind of forced situation of speaking in which we are removed from the right to silence.

This kind of situation led me to produce a project called *Conflicted Phonemes* with Somali asylum seekers who had all been rejected from the Netherlands because of their accents. This is a purely graphic work and as someone who works with sound, it was a moment when I realised the only thing to do was to withdraw the voice, and present the work as a graphic. This took the form of a series of maps that tried to show not the "place-ability" of the voice, but rather its total overwhelming complexity in all of its forms. This first blue image shows the ways in which a voice intersects with a series of political events from the last forty years in Somalia and how that intersection changes forms of speaking. Basically, these are moments in the biographies of the lives of the Somali asylum seekers I met, and here we devised a system where you could divide the northern, southern, and coastal dialects very clearly. As we moved through these systems, each event accumulated more and more ways of speaking, until at the end of the map, you had every possible form of phonation that exists in that context. We also made individual maps for each of these voices, and here you can see the words that caused them to be rejected. For example, one was told that "school" was a northern, not southern, Somali word, and that instead of the word "*masjid*", he should have said "mosque" instead. We devised a way of representing that voice, to show every different language that person spoke, and every different interlocutor they had on a regular basis. It just takes the pure heterogeneity of a refugee camp to show that the closer you get to that voice, the more you get to that one person, you see all of that inter-meshing of languages that surround them.

The voice has long been understood as the very means by which one can secure and advocate one's political and legal interests, but these recent shifts in the law's listening affirm that the stakes and conditions of speech have altered. Therefore, the more radical that the practices of listening at the core of legal investigations become, the more they herald the moment to redefine and reshape the political conventions of speech and sound in society. For now, it seems that the battle for free speech is no longer about fighting to speak freely, but fighting for the control over the very conditions under which one is being heard. For me, a "politics of listening" is therefore a politics that moves away from classic notions of advocacy and of giving people a voice. It is not a call for free speech, or to have an equal platform for all voices to be heard. It is an intervention into, and a reorganisation of, the forms of listening to speech itself. A politics of listening does not simply seek to amplify voices and have issues heard, but rather attempts to redefine what constitutes speech.

Do not pollute others' hearing with shameful sounds.

TOP Lawrence Abu Hamdan, *The All-Hearing*,
2014. Video still. Photo: Tamer El Demerdash.
Courtesy the artist.

BOTTOM Lawrence Abu Hamdan, *Conflicted
Phonemes*, 2012. Installation view from Aural
Contract: The Whole Truth, Casco Utrecht, 2012.
Photo: Emilio Moreno. Courtesy the artist.

How To Do Things With(out) Words

Joshua Craze

" I work a lot with what you could say are "false facts", or facts that don't tell the whole story, and what interests me in terms of art, thought, and inquiry, is how one deals with the falseness of facts. Facts are made and created, and a lot of the facts that I deal with are created in very surreal ways.

For the last ten years, I have been reading redacted documents from the American War on Terror. I first came across these documents as a journalist, while working for The Nation Institute's Investigative Fund. Looking at these documents, you are effectively a detective: among the reams and reams of black that pockmark the pages, there is occasionally a name or a word, such as "Abu Zubaydah". You put these words together and assemble these clues into a web, and then you finally get to tell a story. The story you tell has no sense of the documents in it in terms of their actual physical materiality. That elision was part of an increasing dissatisfaction I felt when dealing with these documents as a journalist. I would read a thousand pages of redacted documents and come out with 300 words of prose and a byline.

There was also something problematic about the way we journalists deal with these documents, because the reader is given no sense of the actual system underlying some of the facts revealed in them—for example, that Abu Zubaydah was waterboarded. It seems to me that much of that system, of detention and torture, was lodged in the documents themselves and in the logic of their presentation, rather than just in the facts that we extracted from the documents and re-presented in our media reports. So I became slightly exhausted with the role of being the one who uncovers what is hidden. What began to interest me more is how one would uncover the system of concealment: the actual system that produces redacted documents. Part of the problem with attempting to do such work is that there are so many redacted documents in circulation, and their sheer number is a kind of "prior redaction" of the documents: the weight and number of the facts, and the weight and number of the pages is such that few people read them.

If you do read them you will come to one page in "Other Document #131"—which is the first CIA report on Abu Zubaydah's capture and subsequent interrogation—that is almost like a piece of conceptual art from the 1960s. It comprises four pages, three of which are entirely redacted in black (although they are now using ink-saving mode, so are using white squares, rather than black). On the first page it just reads: "Black black black black black black black... Abu Zubaydah... black black black black black black black... was... black black black black black black black... waterboarded... black black black black black black... waterboarded." There are many astonishing things about this sentence, the first one being that it is a sentence. It is formed from the elements of other sentences, and yet these words are clearly trying to tell us something. What the CIA is trying to tell you is that Abu Zubaydah was indeed waterboarded, and as journalists we dutifully reported that. What is interesting here is that the logic of visibility in the document, which is to say the CIA's choice of what is visible, absolutely corresponds to what the journalist then reports. The government wants you to know that Abu Zubaydah was waterboarded, and lo and behold we have a report

that Abu Zubaydah was indeed waterboarded. So there is a form of narrative focalisation that happens via the redaction. Certain stories are emphasised, whereas others are not, so it might take us a good ten years to read the Senate Intelligence Committee report and learn about the joys of rectal feeding.[1]

One of the things I began to do was to compile a grammar of the ways in which the redactions themselves became a form of language, essentially conveying messages via the black spaces, via the absence of words. I found logics of redaction within the documents. What interested me about these logics was that none of them were explicable in terms of the putative reasons for redactions. In theory there are legal reasons for redactions: you can redact a document if a government officer or civilian is at risk, or for other reasons of national security. Of course this is a very expansive category these days. But if we take that page from "Other Document #131" I just mentioned, none of those categories can explain why it forms a sentence. None of those categories can explain why the word "was" is left unredacted, swimming in black.

I began to write about the logic of redaction, and some of this work was part of an exhibition last summer at the New Museum.[2] The first logic I analysed was geographic redaction, which was markedly important in the documents relating to the history of the torture memos, which tried to put the CIA's programme of detention and interrogation on a legal footing. John Yoo would be busy, writing the documents, trying to understand whether "Boo Boo"—his name for Abu Zubaydah—was allergic to insects, and then the moment he walks into the White House, everything is redacted: the documents leave no trace of the actual political hierarchy that guided the writing of the memos. In the documents, John Yoo emerges as a sort of puppet, who walks out of the White House, redoubles his work on the memos, as if controlled by unseen hands. Another form of redaction is of subjects. An example is: "black, waterboards, Abu Zubaydah, black, waterboards, Abu Zubaydah, Abu Zubaydah confesses." In theory this type of redaction is done to protect those doing the waterboarding, but you also have whole systems where certain types of subjects, or characters, become identifiable given their proximity to certain verbs or certain logics of geography. This is also the case when you get a type of narrative that is produced simply by the redaction of verbs, such as "Colonel X, black, Abu Zubaydah, black, Abu Zubaydah, Abu Zubaydah confesses."

What I tried to do in analysing these sorts of logics was to understand not so much their content—there are better journalists who have already written about what happened to Abu Zubaydah—but rather some of the logics of government that are revealed in the redactions, and the structures that these redactions take. This was a way of dealing with the falseness of facts. Recently I have been using another approach while working on an essay about Jenny Holzer's paintings for an exhibition at the Venice Biennale, which has now been published as an essay in the catalogue of her exhibition.[3] These paintings are huge silkscreen copies of redacted documents, and

(fig. 1)

(2) an examination of the text, ratification history, and negotiating history of the CAT, which concluded that the treaty "prohibits only the most extreme acts by reserving criminal penalties solely for torture and declining to require such penalties for cruel, inhuman, or degrading treatment"; *Id.*

(3) analysis of case law under the TVPA, concluding that "these cases demonstrate that most often torture involves cruel and extreme physical pain, such as the forcible extraction of teeth or tying upside down and beating"; *Id.* at 2.

(4) examination of the Israeli Supreme Court and ECHR decisions mentioned above, concluding that the cases "make clear that while many of these techniques [such as sensory deprivation, hooding and continuous loud noises] may amount to cruel, inhuman and degrading treatment, they simply lack the requisite intensity and cruelty to be called torture Thus, [the two cases] appear to permit, under international law, an aggressive interpretation as to what amounts to torture, leaving that label to be applied only where extreme circumstances exist." *Id.* at 26-27.

On Friday morning, July 12, 2002, Yoo told ████████ by email, "Let's plan on going over [to the White House] at 3:30 to see some other folks about the bad things opinion. Please stamp draft on it and make two copies (and one for me and you, of course)." Yoo and ████████ met Gonzales at the White House Counsel's Office later that day. It is likely that either Deputy White House Counsel Tim Flanigan or Counsel to the Vice President David Addington was present, but ████████ and Yoo were not certain who else attended this meeting. ████████ orally summarized the memorandum's conclusions for the group and they gave Gonzales and the other attendee a copy of the memorandum for review. According to Yoo, none of the attendees provided any feedback or comments at this meeting.

13

when she first sent them to me, she sent them as PDFs, which was interesting as this made them identical to the documents themselves. So I wondered why she would paint these documents. In some sense it seems a very Warholian project, a "rewriting" of the structural nature of the violence, but the first thing that I thought when looking at them —and they are around three times life-size when you see them in a gallery—is that they are asking us to stop.

As a journalist, when you look at redacted documents, you look at them for information. What Holzer's remediation of these documents as paintings suggests is that there is something going on in them that is not simply information. In listening to people talking about the paintings in the exhibition, it was fascinating that people actually started talking about the documents, and the logic of individual scenes within them. One of the things that happens in journalism is that some of the "madness" of the documents gets excised, and everything becomes very rational and explicable. For example, "He was waterboarded because we believe he had this information, this may or may not correlate to this legal framework, but the White House spokesperson says X." Whereas when you are reading documents such as interrogation files that have been partially redacted, the first thing you see is that they are written in absolutely terrible English.

One of Jenny Holzer's recent paintings is called in (JIHAD) time, and the text in the painting begins, "I that my Renown is mentioned in (JIHAD) time I was a childe", and then "and with my family". When you are viewing the painting, you are constantly forced into the facts, and the reality of the facts, rather than their falseness or the endless "narrativisation" of the facts that one does as a journalist. You are forced into these details and if you listen to people as they walk around this exhibit, it is striking that they hold onto these little details and start to viscerally experience some of what is undergone in these documents. They become stories, rather than huge narratives of "is it justified?" This is not a series of endless TV talking heads debating the ethics of waterboarding. Instead, much like Naeem Mohaiemen's work, Holzer's paintings focus on the anecdote: the strange, unexplained detail in the document.

In an era when things are so endlessly already explained or accompanied by justifications, such forms of marginality and anecdote arrest our attention and offer us a space into history, or into fact. In my work, I have been trying to show the falseness of the facts. Not the truth or falseness that might accompany an assessment of the claim "was Abu Zubaydah waterboarded?", but the falseness of the whole system that might have produced the event of the waterboarding, and the series of assumptions, and indeed the series of fantasies that did produce it—because as we know, Abu Zubaydah, was the first high-value detainee, the leading member of Al-Qaeda—until it emerged that he wasn't. In the words of Donald Rumsfeld: "I'm shocked." There are actually a series of very powerful fantasies that you gain access to through the documents, and through the logic of the redactions, that find no place in journalism, so in my investigation I have been trying,

both via Jenny Holzer's work and in looking at the grammar of redacted documents, to show or to understand if we can show, the actual falseness of the logic of the facts themselves.

1. The Senate Select Committee on Intelligence, *The Senate Intelligence Committee Report on Torture*, New York: Melville House, 2015

2. Craze, Joshua, A Grammar of Redaction, New York: New Museum, 2014, http://www.joshuacraze. com/exhibitions/

3. The essay is called "In the Dead Letter Office", written for the exhibition Jenny Holzer: War Paintings, Museo Correr, Venice, Italy, 7 May–22 November, 2015. A variant of it was published in *Media-N* on 7 May 2015, http://median.newmediacaucus.org/the_aesthetics_of_erasure/in-the-dead-letter-office/

What we mean when we ask permission

Naeem Mohaiemen

"I have been thinking recently about what happens when we collect the stories of others. What are our responsibilities toward an assumption of the felicity of transmission; the move from experiencing to recounting?

The Young Man Was is a project about the slow decline of a certain form of utopian longing, embedded in a revolutionary left project. For this work, I spend a lot of time with older men, often at a stage of semi-retirement (it is also an exploration of a certain doomed masculinity). This stage in life is when they may be assumed to be in a slight retreat from the world. My interest has been to excavate their stories and bring them into dialogue (at least in my own mind, perhaps not in theirs) with a time that moves forward in unsteady motion.

This dynamic of "rediscovery" carries many contradictions. There are three films in the series so far, and in the newest chapter I encountered someone who was not working from within my structures. He did not look at me and think, "You have come to tell my story, now recreate it however you want." Rather, he pushed back in a challenging and generative way, which was a very different experience from the previous two films. There was almost a surrender of will in those earlier films: "I have already lived the event, I do not need to shape the story."

This first clip is from *United Red Army*, a film about the 1977 hijack of Japan Airlines from India to Bangladesh; the film is built from the transcripts of the audio recording of the negotiations.

This is one of the moments when the film turns, and it is also a moment where my version of events and the memory of the hostage negotiator, Air Force chief AG Mahmud, diverge. There were 20 plus hours of negotiation tapes. In the raw transcripts, there is a great deal of content that we could classify as "important". The Japanese Red Army/JRA had aligned themselves with the PFLP or Popular Front for the Liberation of Palestine (al-Jabhah al-Sha'biyyah li-Taḥrīr Filasṭīn). This was a secular Marxist-Leninist organisation, the second-largest Palestinian group after the Palestine Liberation Organization (PLO). On the tapes, the JRA spend a long period with the chief negotiator talking about ways to guarantee that the plane would not get shot down after they leave Bangladesh. The discussion pivots around which countries could be "relied upon" to not allow any other country to shoot down the plane. If you listen to those discussions, it is intensely serious and unrelenting. These moments are what I think the lead negotiator AG Mahmud would consider to be the backbone of history—when two men are talking as "men" (as they think, feel, and enunciate) deciding the course of big events. (Of course much of that masculinist discourse can't be sustained, as you see in the film).

But the actual sequences I chose were far apart from these moments. The alcohol exchange ("not whisky, not whisky"), as well as the newspaper sequence right before, are almost throwaway moments in the "great history" arc. It's only about four minutes out of many hours of audio that I had. But I consciously centred it in a particular way in the film. In the screenplay (not written, but selected on the editing panel) it is the turning point. When you watch the film all the way through—it's 70 minutes long—this moment is an unexpected curve and, when it works, the audience's mood shifts. They are allowed, I hope, the space to start to smile at the unintentional irony of the moment, and anticipate other twists and contradictions that will follow.

and please arrange sending

fruit cup... juice... newspaper

and empty food container

now about the newspaper

to give you the newspaper or not

newspapers always tells lies

most of the time

we ask the newspaper

we like to know the impact

of our action

I will collect two three newspapers

and read out the news items to you

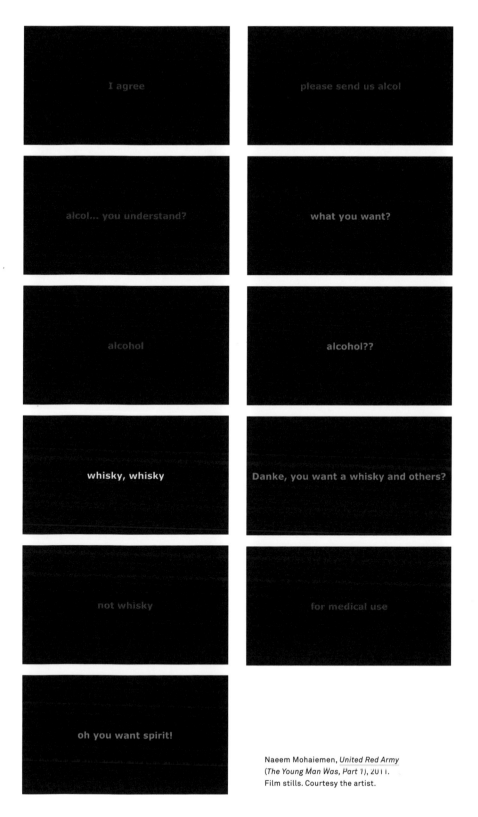

Naeem Mohaiemen, *United Red Army*
(*The Young Man Was, Part 1*), 2011.
Film stills. Courtesy the artist.

What we mean when we ask permission

Mahmud did not necessarily agree with these editing decisions; here he is watching the film at his house. I was very nervous that he would watch it all the way through and say, "This film is not the story I remember." But after watching it, he only said, "This is fine, even though I don't understand why you put the alcohol sequence in." There were a few other sequences that he thought was not the "core of history", but he also accepted the choice.

I have been working through what it means when you make films about a moment that was crucial to the people that were protagonists of the movement. And yet from a distance of 30 years, we are approaching it with some slightly upturned or downturned smiles, some sort of recognition of the heavy ironies of the moment.

And yet, I am not approaching it with cynicism, because my emotional relationship with the revolutionary left possibility is that I did and do think it mattered and continues to matter (even in its long decline). I came of age in the 1990s, at which point much that was at stake had already been resolved (in many cases, sadly and badly). For us, the left was always something that was already in the past. A touch of humour becomes a way to embrace and even care for (and heal) that moment. Humour about this moment doesn't automatically feel cynical for my generation, but perhaps that is precisely because we don't carry the scars on our own bodies. But that humour can feel dissonant to a survivor of that same moment, when they encounter the work. I am not sure if I am able to make myself clear entirely. I feel I could be clearer, but I am treading extremely cautiously because I am overly conscious that these are others' stories, and I am not sure if I have really been given consent to insert ironic notes into their stories.

The second work in this series is *Afsan's Long Day*. This film is about Afsan Chowdhury, a historian who was the victim of a case of mistaken identity. In 1974, the police were going house to house to find sympathisers with the Maoist underground (or other tendencies, all mixed together and misrecognised). They tried to pick up Chowdhury, thinking that he was involved with an armed faction. His library had parts of the "Marxist pantheon, with old Karl Marx on the cover", so that was the main evidence for the searchers. Chowdhury, as a survivor, has a very different relationship to this time period from me—very cynical and clear eyed. I recorded his stories, but ended up coming away and making a very different film from what he had expected. This is Afsan watching the film in Dhaka, when it was completed.

In each of these cases, I seem to be approaching the protagonist with trepidation after the work is "finished".

The document is hardest in the absence of fiction as your distancing device. I wonder if someone will one day say: "I spent so many days talking to you, but all the important moments that I talked about are not here, rather what is in the film are these marginal moments at the very edge of my story—in fact, those were anecdotes I was telling you as I unclipped my microphone, and walked up to the table for lunch, but it seems that marginal anecdote was what drew you in."

Finally, this is part three (*Last Man in Dhaka Central*), which premiered at the Venice Biennale. It's the story of Peter Custers, a Dutch activist, journalist, and academic. In 1972 he was a PhD student at Johns Hopkins, but he dropped out of his programme to go to Bangladesh and document

the underground left in a period when it looked likely to take control of the country, in a replay of the Chinese or Cuban revolution (always in the shadow of 1917). Eventually Peter was arrested, and he was in jail for a year until he was released as a result of pressure from the Dutch parliament. The title is an argument against Francis Fukuyama's *End of History and the Last Man*. It's also, perhaps, a tertiary link to John Kerry's famously mordant comment to the Vietnam subcommittee of the US Senate: "How do you ask a man to be the last man to die for a mistake?"

Of these three men, Peter has been the most invested in the history that he is retelling. Unlike the others, he challenges my storytelling form. He has been involved in the film from the very beginning, and has debated many of my choices. He is someone who continually and steadily asserts the primacy of his own memory and its right to exist without filter.

I think here, there is also something specific about the experience of the revolutionary left in the 1970s, in how that moment and movement, and that time of possibility, is suffused with a sense of sincerity and authenticity—and I don't put quote marks around those phrases when I've used them; it is to inhabit that position with genuine passion.

These three men were willing to give the prime years of their life to a mission—in all three cases, their life was in some ways, altered by their sacrifices, but the promised time did not arrive. It may be unexpected for these protagonists to encounter a relationship of removal from that moment, where we try to insert whimsy or a smile—as a way to turn a moment upside down and have it mean something else. The song lyrics in the opening sequence are from a famous love song from my youth, which I superimposed on top of a phone conversation that Peter is having. He asked me, naturally, "Why is this song relevant to my story?", and I replied that I think of defeated, frustrated romantic love as a metaphor for the leaving behind that had to happen after he left jail.

Peter argues with me about those kinds of readings. At the same time, he also watches the film repeatedly to sharpen his critique. His comrades have also been to Venice to see the film, and one of them told him that the film was "not very radical". This tells me something more about a relationship to histories that is not always collective, nor in consensus. We reframe continuously, and yet the people who live those moments may insist that they still have the right to be heard in their own voices, not necessarily in ours. "

We regret to inform that Dutch journalist, activist, and academic Peter Custers passed away unexpectedly on 3 September 2015. He was 66 years old. A dedicated friend of Bangladesh, Peter was active until the end of his life. Last month he travelled to Venice to watch *Last Man in Dhaka Central* at the Biennale, and at the time of his passing was planning to travel to Lisbon to be a discussant for the film's premiere at DocLisboa.

Tricks

Beatriz Santiago Muñoz

[◄))

"In my practice, I am interested in methods and processes: sometimes I think of them as tricks. I use these tricks in order to mishear, to distract the speaker, to put an obstacle in front of speech, to model, and to break language. Language is made not to be believed, but to be obeyed, so say Deleuze and Guattari in *A Thousand Plateaus*. This is something that I feel is true. I cannot find the specific reference but I know that James Joyce said he either wanted to put a hole through language, or a foot through language, or a bullet through language. This is a good description of what my relationship to language is. What they meant is that we do not learn language as a way to communicate new experiences with the world, we are taught language to obey a particular set of orders. We are not only taught grammatical and literary forms, but we also repeat ideas, narratives, structures, and ways of thinking; eventually we learn to fit our experience into these structures. In the hierarchy of truth and testimony, language seems to take priority. Then there is speech about speech, which is what most of speech turns out to be. We tell what we hear others say, and we forget what is seen or felt.

For most people, language is a faulty machine with a very slim relationship to their personal experience; it can only reproduce a standard set of narratives. Here is the possible proof of this proposal. I am sure you may have had moments of profound suffering. Someone you love has died, or you are very sick. You are in the presence of deep suffering. It is at these moments of profound experience that language is at its most useless. When everything in the world seems obscenely banal, only breaking language into pieces will do. A lot of my work starts off with the process of observation and documentation in the present tense. This means that I spend a lot of time in a place or with a group of people, talking to them, or just being with them when I shoot film. If I do interview someone, which is rare, it is usually so that I can spend time with them.

So this is my first method, or my first trick, to let time pass and to go very slowly, to change my own perception of time. I spent a lot of time speaking to Elizam Escobar, a Puerto Rican political prisoner, writer, and artist, who spent 19 and a half years in jail. If there is someone with a well-constructed edifice of language around his experience, it is Elizam. All of his experience is constructed through a political understanding of his own history. Because of that, it was very hard to get to where I wanted to go, which was his sensorial world during his time in prison. As he is a very intelligent man, he recognised this, and knew that we were never going to be able to get to this place through speaking. So he gave me his diaries from his prison years. During this time, Elizam's heightened sensorial awareness allowed him to see the detail of his mental processes, and develop a relationship to his limited material world in an ever-expanding form. Like the few seconds of a car crash that seem to expand into interminable minutes, Elizam recorded in detail the life of a spider with which he shared his prison cell, and the smell of the cleaning detergent that he had to scrub the wax floors with; all of these moments expanded in his mind, and in the text they seemed to have no end. He was able to see and describe, in detail, the mental processes that to us would be invisible. But the recollection of that heightened sensorial moment is impossible. He even says someone else served his time for him and he is thankful to

that other Elizam. *Prisoner's Cinema* uses only text from this diary, except for one specific moment.

Here is the second trick: put an obstacle in front of speech. This is a trick I learned in an acting class decades ago. I use it all the time; actors will recognise this. First you memorise the script like a phone book without inflections, without affect. You take the sense out of it. Then you give yourself a task. Fix your shoe, mop the floor, it doesn't matter. While your body is occupied, you perform this script and let it come through you. For actors this is a trick that is meant to disable all the controls we have over that speech, and to open up other ways of being with a text. It does not change the script, but changes the way it comes through you. I do this constantly to others. I speak to people while they are mopping, riding horses, dancing. It also exhausts you, which is another trick, but one that works on other levels.

In 1979 Carlos Irizarry, a Puerto Rican artist, boarded an American Airlines plane and threatened to blow it up in support of the liberation of Puerto Rican prisoners. The work *Esto Es Un Mensaje Explosivo* looks at this as an event that has been understood either as conceptual art or as a terrorist hijacking. Carlos actively constructs his narrative, breaking it into these two categories that mutually exclude one another. If it can be understood as art, then it cannot be a political action, and if it can be understood as a political action, it cannot be art. One of the things that I was interested in doing was confusing the categories again, which is not something you can so easily do with speech, which is why it is done instead using movement. In the film, Irizarry first talks about the event, followed by a retelling of the event, immediately afterwards, through movement. As he states:

> In fact, when I was in prison, because of this conceptual art issue—I was not supported by the groups organized to fight for the release of political prisoners. Because they did not consider me a political prisoner. Because it was a conceptual art work. In truth, it was Marco Rigau's invention. He was the one who thought of this, for the legal defence. And it worked perfectly well, let me tell you. Because otherwise, I'd still be in prison. The defence of my case, was based on conceptual art. But what I did has nothing to do with conceptual art!

The last method, or procedure, is to listen to any talk as you would listen to a dream. I try to look for the detritus, the repetitions, symbolic objects that mean nothing at all, such as broken furniture that is just placed there through habit. Most of all, I try to pay attention to the feeling at the centre of the dream. Here is Pablo Díaz Cuadrado in my film *Matrulla*. In 1972, he had a hallucinatory trip with a tea made from Brugmansia flowers, and in it he saw his future house, built in Orocovis, which means "first mountain", situated in the central mountain range of Puerto Rico. He built the house from the dream, using an assemblage of discarded materials around this tree. In this place Pablo quietly tests alternative ways of living. He plants and stores ancient grains, accumulates the debris of progress, and supervises the decomposition and reconstruction of everything that

TOP Beatriz Santiago Muñoz,
Prisoner's Cinema, 2013. Film still. HD
video, colour, sound. 31:00 minutes.
Courtesy the artist and Galería Agustina
Ferreyra © Beatriz Santiago Muñoz.

BOTTOM Beatriz Santiago Muñoz, *Esto
Es Un Mensaje Explosivo*, 2010. Film still.
HD video, colour, sound. 16:36 minutes.
Courtesy the artist and Galería Agustina
Ferreyra © Beatriz Santiago Muñoz.

surrounds him. He prepares himself for the moment when water and food
will no longer be available. He is there now, in the future, collecting seeds,
a rear guard visionary.

One of the things I try to do in my work is to make space when I am with
the person that I am working with. I try not to take content and retell it in a
space or a moment outside of that context; I want us both to be there and
make decisions, for that person to know how it is being transformed. This
means I have to convince them to dance with me, play with me, or dwell on
things in that moment—it cannot happen afterwards. It has something to do
with slowness—it requires that time and that slowness rather than taking
and remaking a "moment". One needs time to be able to observe and think
about how that moment is constructed, how it contains the history of all the
other experiences in both their lives and mine. The history of the camera
device itself adds a lot of information that you do not choose, but that is
inherently part of the work. ”

Community

Action

Reciprocity

Co-determination

Algorithmic Listening and Communicative Democracy

Seeta Peña Gangadharan

In *Inclusion and Democracy*, Iris Marion Young argued that respectful communication norms—principled practices that guide how we interact with one another—are a, if not *the*, critical component of a fair and just society.[1] This argument emerged in reaction to procedural theories of justice which took specific examples of democracy from history, "disappeared" contextual factors that surrounded these democratic practices— such as slavery, indentured servitude, and other forms of subjugation that contradicted principles of equality and liberty—and then used these decontextualised cases as normative models of communication. Young contended that, from Rawls[2] to Habermas,[3] communicative norms rested upon a rational-only mode of being.

Young rejected these dispassionate communicative models as exclusive, suggesting, for example, that though everyone might be invited to the town hall, some participants would experience "internal exclusion". If impassioned speakers in the room voiced their concerns, others in the meeting would dismiss their appeals or proposals as irrational, stop listening to them, and effectively negate their presence. This form of exclusion is differentiated from "external exclusion", which bars certain individuals or groups from entering a discussion.

Young viewed modern society as being prone to internal exclusion. For her, though society had grown more complex, and styles of communicative expression more heterogeneous,

power holders routinely practiced internal exclusion, giving the impression of welcoming all groups to political conversation but effectively blocking some from involvement in debate and decision-making about their life paths and destinies. For example, low-income communities of colour in the United States might be invited to a discussion about police accountability and criminal justice. But because these individuals express themselves variously—with a poem, rap, or physical movement—their sentiments about policing are de-emphasised, dismissed as parochial, disparaged as obstructionist to what decision makers might call "the real task at hand".

Young offered communicative practices that privileged historical context in communication and acknowledged a link between modes of communication and the substance of ideas communicated. 'How' people communicated was as important as 'what' people were trying to convey, and Young created a set of norms that honoured how and what. No participant could speak with entitlement. A commitment to hospitality guaranteed that participants would be invited to discussion with impartiality for their style of speaking. Participants had to speak at a level of generality graspable by all. Listening had to take place with a willingness to hear others, move along discussion, and respect others' differences.

This was the key to social justice. If society were to accept and acknowledge its variety and complexity and permit all types of individuals to meaningfully participate, it had to aspire to an adequately varied and complex set of communication practices. Only then could society claim to be democratic, affording all individuals and communities the opportunity to participate in the decision-making that affects people's capacity to collectively self-govern.

[Accounting for New Technologies of Listening]
While the model of communicative democracy proposed by Young works to remedy the problem of internal exclusion and creates a

more capacious theory of justice, it does so in the absence of an account of the role of technologies in transforming the communicative diversity of modern society. While speaking of internal exclusion, Young referred to the distorting effects that, for example, broadcast media could bring to political discussion. But beyond describing television's distorting powers, she did not articulate any broader understanding of the social or technological trends that fuelled the capacity of the media of communication to amplify or inhibit people's ability to speak and listen with reciprocity and respect. She was, in fact, concerned primarily with the face-to-face meeting.

In 2015, an account of communication technology within a theory of justice seems wanting. Today, modern society makes it difficult for individuals to interact independent of networked digital communication systems. From government and commercial services that have become digital only, to schools which privilege computer tablets over books or workplaces, that rely on computer monitoring to determine productivity, most individuals in society are connected to a digital information infrastructure whether they have a home subscription to the internet, have signed up for a personal email account, or own their own digital device. To a certain extent, all individuals are digitally included, whether they seek out digital connections or not.[4] In other words, digital inclusion is not a choice; it is a condition.

Within this digitally dependent environment, listening has become algorithmic. Machines collect massive amounts of data produced by consumers who communicate through computerised devices and leave digital traces of themselves, by entities converting analogue records into digital ones, as well as by institutions recording human behaviour—with or without the consent of those being observed.[5] Engineers then design analytic models or sets of algorithms designed to "listen" to data, detecting patterns among attributes found within databases and identifying probabilities of relationships, similar factors, or correlations. Based upon this specific

form of categorical listening, engineers can then apply these algorithms to other kinds of data, or new data, and make a prediction, offer a recommendation, or trigger a decision or action for humans interacting with a data-driven system.

Some of the most common forms of algorithmic listening—for example, Amazon recommending a particular book to a user or Google providing a set of search results—are harmless and potentially beneficial. But algorithmic listening can also contribute to problems of internal exclusion, whereby predictive, data-driven systems exacerbate discrimination or exploitation of members of historically marginalised groups. Certain individuals' and their groups' interests are effectively ignored because algorithms are unable to capture and analyse relevant data points that would effectively represent collective self-interests. Algorithms—or more accurately, the individuals and institutions who decide to deploy them—analyse available data independent of the context and history from which they originated.

The use of algorithmic analysis in the targeting of subprime mortgages is one such case of problematic algorithmic listening. Throughout the late 1990s and 2000s, the subprime industry took advantage of predictive technologies to identify and target consumers with low-credit ratings (ie, high-risk borrowers).[6] Through the collection, aggregation, and analysis of a variety of different data sources, the mortgage industry targeted members of underserved communities for purchase of first-time subprime mortgages, home equity loans, and refinanced mortgages.

Lenders purchased credit profiles of particular geographical areas and merged the demographic data to identify prospective minority borrowers. They also collected data from sites, such as bankrate.com, where users voluntarily entered personal data about themselves to estimate mortgage rates. Armed with these data profiles, lenders worked with brokers and marketing firms to develop promotional techniques for persuading

minority populations to purchase subprime products. As one former employee testified during a case against Wells Fargo, not only did staff refer to subprime mortgages as "ghetto loans" but the bank also "had software to generate marketing materials for minorities", including materials that spoke the "language of African–Americans".[7]

The impact of subprime lending on African Americans has been profoundly devastating. African Americans were first in line to be targeted and are now last to recover from the financial crisis' effects. For example, in a canvas of 200 metropolitan areas, researchers found that Blacks were three times more likely to receive a subprime loan for first-time home purchases than whites.[8] In neighbourhoods that were predominantly Black neighbourhoods, rates of high-cost subprime loans were significantly higher than in more diverse residential areas.[9] Today, regulators and consumer advocates report that the financial implosion wrought by the Great Recession wiped out a generation of economic progress and could impede the financial stability and mobility of African Americans for decades to come.[10] Communities with high rates of foreclosures (of subprime homes) also face high rates of unemployment and experience public health problems, including higher suicide rates.[11]

Though algorithms were not the only factor that propelled the subprime mortgage crisis or the cumulative disadvantage that has resulted, algorithms played an often invisible, but critical role. Algorithms listened to consumers in ways decoupled from a longer history of predatory targeting of African Americans. Lenders, brokers, marketers, and other actors in the subprime industry who relied on the success of algorithmic targeting chose not to acknowledge other data points that spoke of risk or harm, and the algorithmic form of listening they elected was akin to a form of internal exclusion: African Americans were active participants in digital society, and lenders and related actors ensured that they obtained, analysed, and exploited data

profiles to promote "reverse redlining", which helped perpetuate financial ruin for a group historically beset by economic hardship.

[Confronting Categorical Communication]

An updated version of Young's just and fair society could go a long way in developing communication norms not only for human participants but also the predictive, automated systems that mediate humans' participation in debate and decision-making. Today, society is problematically dependent both on rational communication, as Young described, as well as on "categorical communication", computerised processes that lead to the data profiling of individuals. Different from how individuals and their communities define themselves, their needs, and their wants, categorical communication results in a representation of an individual based upon attributes a digital machine observes, records, and analyses.

A reasonable place to start is by considering how intelligent systems might incorporate history and context in otherwise agnostic algorithmic processes. How do individuals and institutions that develop algorithms interact with the predictive systems they create? Do algorithms get the last word or do humans get to intervene, explain, compare, or relate outputs produced by a predictive system? What are algorithms *not* listening to or analysing, and how is the absence of that kind of data creating a particularised form of listening, and in some cases promoting bias, discrimination, or unfairness?

Until institutions and individuals most closely tied to these systems engage with these questions, an inclusive, communicative democracy—one that allows all individuals and groups to meaningfully participate and shape shared destinies—will remain a myth.

1. Young, Iris Marion, *Inclusion and Democracy*, Oxford: Oxford University Press, 2000.
2. Rawls, John, *A Theory of Justice*, Cambridge, MA: Belknap Press of Harvard University Press, 1971.
3. Habermas, Jürgen, *The Structural Transformation of the Public*

Sphere: An Inquiry Into A Category of Bourgeois Society, Cambridge, MA: MIT Press, 1989.

4. Eubanks, Virginia, *Digital Dead End Fighting for Social Justice in the Information Age*, Cambridge, MA: MIT Press, 2011.

5. Pasquale, Frank, *The Black Box Society: The Secret Algorithms That Control Money and Information*, Cambridge, MA: Harvard University Press, 2015.

6. Fisher, Linda E, "Target Marketing of Subprime Loans: Racialized Consumer Fraud and Reverse Redlining", *Brooklyn Journal of Law and Policy*, vol 18, no 1, 2009, pp 101–135.

7. Fisher, "Target Marketing of Subprime Loans: Racialized Consumer Fraud and Reverse Redlining", pp 101–135.

8. Been, Vicki, Ingrid Ellen, and Josiah Madar, "The High Cost of Segregation: Exploring Racial Disparities in High–Cost Lending", *Fordham Urban Law Journal*, vol 36, 2009, pp 361–393.

9. Been, Ellen and Madar, "The High Cost of Segregation: Exploring Racial Disparities in High–Cost Lending", pp 361–393.

10. Mui, Ylan Q, "For Black Americans, Financial Damage From Subprime Implosion is Likely To Last", *Washington Post*, 2012, http://www.washingtonpost.com/business/economy/for-black-americans-financial-damage-from-subprime-implosion-is-likely-to-last/2012/07/08/gJQAwNmzWW_story.html

11. Mian, Atif, and Amir Sufi, *House Of Debt: How They (And You) Caused The Great Recession, and How We Can Prevent It From Happening Again*, Chicago: University of Chicago Press, 2014.

Strong People Don't Need Strong Leaders:
Intentionality, Accountability, and Pedagogy

Robert Sember

(Ultra-red)

For 20 years, the members of the international sound art collective, Ultra-red, have undertaken militant sound investigations alongside and within political communities. This work involves developing and sustaining long-term collaborations with specific constituencies and political struggles in the cities where we live. Ultra-red explore how practices of intentional listening can support long-term political organising. While we consider how listening is addressed in political theory and philosophy, our work is first and foremost about practice: how do we organise our politics and what form does listening take in the organising process? These efforts are intended to complement the ways in which speech, imagery, gestures, and many other operations are used to advance political struggle. Far more attention has been given to these operations than to the literacy of listening at the level of social action and organising.

Ultra-red formed in 1994 when musicians involved in the AIDS activist movement in Los Angeles helped establish and run harm reduction programs for people who inject drugs.[1] Three years later community members in Union de Vecinos (United Neighbors) based in East Los Angeles joined Ultra-red and initiated efforts to support struggles for affordable housing.[2] The collective's membership expanded again in 2001 to include social researchers and educators embedded in the struggles of migration and anti-racism in Germany. In 2007, the collective launched long-term initiatives in the United Kingdom with constituencies involved in anti-racist, (im)migrant rights, and housing struggles.[3] Finally, in 2009, Ultra-red members in New York built on decades of organising within the city's black and Latino/a transgender, lesbian, gay, and bisexual communities to initiate projects in support of collective struggles for racial, gender, and economic justice.[4] The initiatives in Los Angeles, New York, London, the southwest of England, and Berlin continue to this day and are the primary source of Ultra-red's political and methodological practices. We share our process and outcomes with collaborators and allies in our home cities and the many constituencies we collaborate with elsewhere on short-term projects.[5] Ultra-red present these practices as a modest contribution to the widespread field of militant inquiry, by which we mean the organising of radical political movements that seek to negate the oppressive structures of capital, racism, gender oppression, nationalism, and imperialism.

The first aspect of collectivity I would like to underscore is that it is an intentional practice. Members of collectives learn how to operate and sustain their collectives through dedicated effort. This means that collectives spend a portion of their time together reflecting on how they are organised and operate. They make explicit the protocols used to guide their efforts and, when useful, draw on and adapt tools developed by other collectives. Thus, Ultra-red, in addition to evolving as a collective and learning from that process also explore and draw on practices employed in participatory democracy, pedagogy, and various forms of economic cooperation and collaboration. We focus specifically on how practices of intentional listening are developed and employed in these various forms of collectivity and how they are used both to listen to how the collective functions and as part of the collective investigation process. By rooting the collective investigation in listening we stall or perhaps foreclose the

temptation for movements to seek out and rely on intellectual patrons to define the terms of struggle, which ought to emerge from the combined efforts of every member of the collective.[6] An investigation based in listening ensures: (1) the development of widespread literacy within the collective; (2) ongoing learning through the phases of reflection, analysis, and action that define political struggle; and, (3) that the collective's primary form of leadership is its shared practices, knowledge, and principles.

A second essential dimension of collectivity concerns the shared commitments and political investments that bind members together. In Ultra-red, we refer to these as the "terms of accountability". Accountability is the overarching intention of collectivity. For Ultra-red, the question of political listening attains urgency because of our commitment to the needs and interests of specific constituencies. Entering into relationships of accountability can bring the objective characteristics of our political investments, the principles that inspire our activism, into conflict with the day-to-day work, the slog of struggle. This may register, for example, as a contradiction between the principles for which we struggle and how the collective is organised. When this contradiction reaches the point of crisis we experience an acute disjunction between our individual desires and investments and the collective's commitments and procedures. We may find ourselves thinking: "I love the cause but I hate the struggle, especially some of the people in the struggle." The tension between ideals and practice is often most challenging for those of us who hold to petite bourgeois notions of intellectual and creative freedom and the entrepreneurialism and individualism they support. From within such a framework, collectivity, even when a part of one's everyday life, confronts the individual as one's opposite. Either one is an autonomous self or one is bound within a collective. What are in fact mutually constitutive terms become thought of and experienced as mutually exclusive and even antagonistic. How we analyse the contradictions in which we find ourselves will determine how we act—either we leave or we invite others in the collective to explore, to listen to the contradiction with us.

We know from experience that movements sustain themselves in large part through their capacity to develop useful listening protocols. These protocols may be created by and for the collective or adopted from existing social practices, such as those used in classrooms, or by families, church groups or other movements. We have witnessed how the absence of deliberative procedures for collective listening results in all manner of obstacles within a movement and its contestations with state power and class masters.

Intentional listening brings speaker and listening into a dialectical relationship. Another way of saying this is that collectives constitute knowledge through their shared exchanges rather than as a result of each individual contributing something particular and unique to the process. When a collective functions in this manner, the voice of its members is realised through the syncretic action of the listeners. Listening in this way means that the action of speaking and listening are not complete until the question, "What did you hear?" is asked and answered, and a dialogue is produced. The dialogue moves beyond the reiteration of established terms

for a struggle by placing those terms in relation to the changing conditions of the base community, the constituency, and the lived experiences of the collective's members. The estrangement of established analyses through collective dialogue presents great opportunities for the development of dynamic political voices.

Organisers, activists, and base communities may resist intentional protocols of listening because they feel inauthentic or unnatural. That resistance can reveal conflicts between competing protocols and even the friction between underlying ethical systems within a movement. The sociologist Francesca Polletta has pointed out that movements organised around the informalities of friendship can find intentional processes inauthentic.[7] Protocols demand a reorganisation of relations and even a shift in ethical foundation from affinity between friends to a concern with the stranger or outsider. Through these, often painful, episodes of transition and re-examination, the existing protocols of listening come under scrutiny and risk seeming strange and unnatural. It could be said that listening as a political practice is always an encounter with the stranger or an invitation to the strangeness in our midst.

A third dimension of collectivity involves the question of pedagogy. The move to collective listening can be an opportunity to diminish or dilute the tendency for a collective to be organised around a single personality or particular authority. Related to this issue is the difference in the roles individuals can play within collectives. A particularly important distinction to be made is between the individual as organiser and the individual or collective as the protagonist of struggle.

In Ultra-red's consideration of leadership, we often turn to the legacy of the civil rights era educator and organiser, Ella Baker.[8] In the 1930s, Ella Baker directed the Young Negros Cooperative League and helped organise Harlem's Own Cooperative that provided milk and other basic groceries to residents in the neighbourhood. Later, as an organiser for the National Association for the Advancement of Colored People (NAACP) she helped increase membership exponentially. However, it was her work with the Student Nonviolent Coordinating Committee (SNCC) that was truly innovative. Under Miss Baker's guidance SNCC members developed a practice of disciplined attentiveness and active questioning.[9]

Working closely with poor, rural communities in segregated Southern states, SNCC activists used active listening to assist communities to build leadership from within in order to solve their own problems. Even when the work of SNCC consolidated around voter-registration campaigns, the primary aim was to develop and reproduce leadership within and among the community itself. SNCC activists were not the protagonists of the movement; they were its organisers. When asked about the role of Ella Baker in the movement, SNCC alumni talk of how she listened and questioned, compelling the movement to be clear about its methods and goals. This pedagogy of listening equipped SNCC field organisers to be organisers rather than leaders with the aim of building local, autonomous communities that could make their own decisions regarding whether and how to participate in the national civil rights movement and transform the country's racially defined class structure.

Ella Baker's practice was informed by forms of horizontal and participatory democracy in US political movements that extended back to the early anti-slavery movements of free Black men and women and their allies in the Quaker-dominated abolition movement. These deliberative procedures would, in time, inform the early labour movement. In labour colleges such as Brookwood Labor College in the 1920s and 1930s, deliberative processes would serve as the basis of experimentation with democracy, often to the deep consternation of the trade union hierarchy who saw democracy as a threat. As part of her training at Brookwood Labor College, Baker came to a lifelong commitment to the inextricable relationship between community pedagogy and organising where the link between the two articulates a specific notion of the political protagonist within the base community.

The role of the pedagogue-organiser is to nurture leadership within the community as a whole, by listening and questioning. This was in sharp contrast to more traditional forms of community organising, which sought to identify strong personalities within the community and raise up those individuals as leaders who stand in for and represent the whole of the community. Miss Baker's assertion that "strong people don't need strong leaders" is as good a definition of collectivity as one could wish for and has been taken up by countless organisers committed to long-term struggle. The emphasis on collective leadership is realised in Ella Baker's conviction that the pedagogical process has the capacity to locate political education at the centre of organising and thus contributes to the transformation of the community as a whole and not just one talented individual or vanguard. The irreducible practice of that pedagogy is collective listening.

How collectives arrive at their deliberations is as diverse as the situations in which communities organise themselves. Yet in each situation, there remains the need for a protocol for deliberation; that is, a protocol for organising collective listening. Even when the protocol takes as its object the written word, a text, an image, theatrical sketch, video or film, choreographed movement, farming or any other form of labour, or any other object, listening becomes crucial as the collective begins to reflect upon and analyse its experiences. What we hear swiftly becomes a lesson in how we hear. This fact is often overlooked in the rarefied discourses of art and sound art theory that, by aligning with the analytical proposition of art (art that interrogates the ontology of art), asserts the priority of the idea over experience. This extends the modernist project while refusing to address the problem of practice in its material conditions, including its class contradictions. Hence a final concern: as the art world becomes increasingly interested in collectivity, will these practices too become reified in order to circulate as abstractions in the global flow of exhibitions, biennials, and surveys? Will they be confined to relationships of representing or looking at, rather than transforming or practicing with? There is a world of political difference between these forms of engagement.

1. Listen to "An Archive of Silence", http://www.publicrec.org/archive/2-04/2-04-002/2-04-002.html

2. See Leavitt, Jacqueline, "Art and the Politics of Public Housing", *Planners Network: The Organization of Progressive Planners*, 24 October, 2005, http://www.plannersnetwork.org/2005/10/art-and-the-politics-of-public-housing/ and listen to "The Debt", http://www.publicrec.org/archive/2-03/2-03-011/2-03-011.html

3. Listen to "Border Sounds", http://www.publicrec.org/archive/2-02/2-02-005/2-02-005.html; "Play Kanak Attak", http://www.publicrec.org/archive/2-02/2-02-003/2-02-003.html; "Eurodac Express", http://www.publicrec.org/archive/2-02/2-02-002/2-02-002.html

4. View "Vogue'ology I", https://vimeo.com/25758841

5. A comprehensive overview of Ultra-red's current work, including extensive methodological tools are available in Ultra-red, *URXX Nos. 1-9: Nine Workbooks, 2010-2014*, London: Koenig Books, 2014. Ultra-red has also made available a three-part, instructional video that introduces the basics of militant sound inquiry. These videos were commissioned by Los Angeles Contemporary Exhibitions (LACE) as part of the "Practice Sessions" initiative on artists' practices. The videos are available at http://welcometolace.org/lace/practice-sessions/ultra-red/

6. See Benjamin, Walter, "The Author as Producer", *Reflections: Essays, Aphorisms, Autobiographical Writings*, Peter Demetz ed, Edmund Jephcott trans, New York: Schocken Books, 1978. As Walter Benjamin describes it in this essay, conventional activist-art stages an encounter between an intellectual in possession of a specific political analysis and a viewer who receives that analysis. This intellectual or ideological patron concerns herself or himself more with that moment and mode of delivery than with whatever effects it may produce. This partition provides the intellectual with an alibi for whatever actions her or his ideas may generate out there. Hence Benjamin asks intellectuals to think less about where they stand on an issue, which leads to representations of suffering, than to think about their "position in the process of production", how their labour is directed, for example, to the reproduction of the class system. "This reflection leads, sooner or later", Benjamin writes, "to observations that provide the most factual foundation for solidarity with the proletariat" (p 236).

7. Polletta, Francesca, *Freedom Is an Endless Meeting: Democracy in American Social Movements*, Chicago: University of Chicago Press, 2002.

8. See Ransby, Barbara, *Ella Baker and the Black Freedom Movement: A Radical Democratic Vision*, Chapel Hill, NC: University of North Carolina Press, 2003.

9. In his recounting of this process, John Lewis writes: "We were meeting people on their own terms, not ours.... Before we ever got around to saying what we had to say, we listened. And in the process we built up both their trust in us, and their confidence in themselves." Lewis, John with Michael D'Orso, *Walking with the Wind: A Memoir of the Movement*, New York: Simon and Schuster, 1998.

Listening to the Converted: Critical Looks at the Social Algorithm

Pablo Helguera

In a text titled "The Future of Music", John Cage wrote:

> Wherever we are, what we hear is mostly noise. When we ignore it, it disturbs us. When we listen to it, we find it fascinating. The sound of a truck at fifty miles per hour. Static between the stations. Rain. We want to capture and control these sounds, to use them not as sound effects but as musical instruments.[1]

Cage's recognition that incidental sounds, bracketed in a particular time and place, could become part of an artwork had profound consequences not only for musical composition, but also for conceptual approaches adopted by a wide range of contemporary artists. It was particularly applicable to the idea that an artwork is not given content, but rather that the container is the content, as it were, and that whatever goes inside will only become the substance of the work. This is a compelling premise, and in some ways prefigures the dominance of the algorithm in contemporary life, as well the current reality of the information age, where systems of content delivery (search engines, social media apps, etc) have come to define our lives, as well as the ways in which we generate ideas and communicate them to others.

One thing to keep in mind, however, about this artistic approach that marks the culmination of the introspective critical view of modern art, is that its practice requires a formalist, interpretive approach of the work—one where the primary content is embodied by the form. This is to say,

for instance, that a work like *4'33"*, whenever experienced by an audience, is always remarkable not because of the particular interpretation or reception of the work—or rather, the quality or types of sounds that may occur during that period of time—but because the formal structure conceived by the artist offers a context in which, as long as the basics of the piece are maintained, it doesn't matter what is heard, or what does or does not happen during that period. What matters is that the artist has created a work whose structure is to indicate to the listener the need to hear the voluntary or incidental sounds during that time, and assume that as the work.

Indeterminacy thus had a powerful and defining influence on the works produced over the last 50 years in the visual arts, ranging from film and performance art to drawing and sculpture, and for this reason, I would argue, the way it is accepted and understood amongst artists today is not dissimilar to the way in which perspective was accepted and understood in the French Academy 150 years ago. Because of its potency and artistic pedigree, it becomes a difficult principle to challenge. And yet this is precisely what one needs to do when trying to negotiate the relationship between conceptual and performance practices and emerging experiments in socially engaged art.

Artists like Santiago Sierra have used the indeterminacy principle in their conceptual/ political work by applying it as a cold formula, using the monetary transaction as the basis of the work. The unethical aspect of Sierra's works has been discussed extensively; what I would like to point toward is the fact that what happens when, or after, the work is enacted, is never as important as the proposal itself. This privileging of the conceptual idea in an ephemeral artwork, over the material circumstances and results of its enactment, is similar to the way landmark performance artworks of the 1970s have been largely historicised. Judging from the minimal documentation of grainy black and white photographs and brief descriptive captions, it is impossible for us to prove exactly how some of these performances took place in real time. What ultimately matters in these cases is the idea,

and its artistic value is appreciated based on the visual "evidence" and the narrative provided by the artist or others.

Sierra's work is only one of many examples of how the contemporary use of the social algorithm, whether we object to it in ethical terms or not, has become a valid and widely used conceptual strategy. This is also, I believe, why this kind of established approach is commonly employed in socially engaged art, where artists conceive of a work in the solitude of their studio and proceed to apply it, in the fashion of a performance score, into real life situations.

The problem with such an approach is that socially engaged art is a practice that, while drawing on the legacy of post-minimalist practices such as performance art and institutional critique, is completely dependent on the type and quality of the participant response. In other words, what is sought in the interaction with other individuals is not the indifferent playing out of a conceptual script that has been previously concocted, but the actual construction of a communicative action (in Habermas' words) that is shaped by both artist and participant.

The interest in producing participatory experiences in art over the last decade, particularly in the United States, has also resulted in some kind of push for "theoretical reinforcement"—that is, the need to justify our work both on the grounds of politics and aesthetics. The fallback position in artistic terms is that socially engaged art produces models of experience for participants to inhabit and benefit from, while in political terms it is generally assumed that these models, which possess varying degrees of antagonism or altruism, contribute to the betterment of society through reflection, awareness, and a call for action.

In practice, however, many artists who produce participatory models rely heavily on rigid structures (ie "rules of engagement") that do not allow for much flexibility in their live application. In this sense, the project becomes implemented by following a preconceived conceptual score, with little consideration of the fact that the unfolding of the experience cannot be completely controlled.

This is the instance where the act of listening becomes critical. In the conceptual tradition of indeterminacy, it is tempting to create a space for "listening" where all can express themselves. But if allowing the participant to inscribe their opinion is only permitted in a pre-established space, this is not too different from the community murals where each child is given a mosaic to decorate: the individual input becomes ghettoised, and as dozens or hundreds of interventions are placed together, they simply negate one another. As in the case of the Cage piece, what dominates is the compositional principle—the grid that organises the random information that enters into the composition. In this case, the individual voices become noise.

In socially engaged art, listening is irrelevant if what has been listened to is not assimilated into the very structure of the work. For that reason, a project that proposes the act of listening without being willing or ready to act in response, easily morphs into a "speakers corner"—an open plaza where anything and everything is said, with no major consequences or implications. This is to say that the conceptual art tradition, when simply superimposed onto the practice of socially engaged art, objectifies an otherwise dialogic process and turns it into a monologue—a uni-directional statement by the artist that does not need a response from the public.

We therefore need to think of the elements of what I would term as "social composition" —a form of work initiated with what can be considered an authored premise, but one where the response from the participants helps shape the experience in a collaborative way. Cage's proposal for a composition was to bracket existing sounds and embrace them as part of the artwork. Today we need to go beyond the bracket—that is, beyond the simple act of listening—to shape the work itself. Paraphrasing Cage, wherever we go we find social noise. When we ignore it, it may disturb us, but if we were to listen to it, we would find it fascinating.

1 Cage, John, *Silence: Lectures and Writings by John Cage*, Middletown, CT: Wesleyan University Press, 1961, p 3.

Repellent Fence: When Land Becomes Shared Metaphor

Kade L Twist

"One thing that I want to say right off the bat is that I am not advocating for any specific kind of truth. As an artist with Postcommodity, I don't think that we seek to advocate for one truth; we seek to advocate for complexity and dialogue, and the truth that we have found comes through the negotiation process. So, one philosophy that I would like to put forward is "transdisciplinary learning or listening". Something that we have found in our work, particularly in Canada, in Guelph, Ontario, and on the Mexico-US border, is the significance of facilitating community epiphanies through collaborative processes driven by shared intentions, because these epiphanies often lead to the production of co-defined metaphors that advance community self-determination. When this happens, it is a very powerful experience, much like the transformative phenomenon of ceremony, because it is lived, shared, and entirely based on a contextualised intersubjective encounter. But reaching that point requires a lot of listening, respect, reciprocity, patience, interdisciplinary diversity, and community driven strategies that advocate for a community's own capacity, reinforce leadership, and mobilise people into action.

I would like to focus on one particular project that we have been working on since 2007, *Repellent Fence*. It will be exhibited from 9–12 October, 2015, and I hope that while I provide an overview of this project, I will be able to communicate the power of co-intentionally creating a metaphor for community self-determination. The borderlands are incredibly beautiful, and populated with resilient, resourceful, and generous people—old school, salt-of-the-earth people. But this landscape is also the most contested, surveilled, and militarised space of the Western Hemisphere, where there is a palpable intensity and an unmistakable anxiety present. We are currently working in Douglas, Arizona, and Agua Prieta, Sonora, and there is a border port of entry near Douglas. *Repellent Fence* is a two-mile-long ephemeral monument made of ten-foot diameter vinyl spheres inflated with helium that float 50 feet above the landscape, intersecting the Mexico-US border, one mile on each side. The vinyl spheres are enlarged replicas of "scare-eye" balloons, which are the size of a beach ball. You can blow one up and hang it in your garden or trees and it scares away birds for a short period of time. Soon it will be covered in bird shit and the birds will be trying to have a party on it.

However, from Postcommodity's perspective, this failed consumer object is semiotically loaded. If you look at its colours, they are actually indigenous medicine colours used throughout the Western Hemisphere—yellow, red, black, and white. If you look at the iconography itself, you are looking at what is known as the "open eye"—an indigenous iconography used for thousands of years by tribes from South America all the way to Canada. So with this off-the-shelf consumer object, we have a semiotic vehicle that does a better job demonstrating the interconnectedness of the hemisphere than it does scaring away birds. Like a lot of consumer objects, it has many layers of meaning, from embedded obsolescence to the futility of the product itself, but for us, it means something that has been long forgotten in this hemisphere. We, as indigenous people of this hemisphere, whether full-blooded or of mixed ancestry, are intensely interconnected. We have a record of shared culture, religion, worldview, language, and iconography that clearly demonstrates this reality.

People coming into the United States from Central America, South America, and Mexico are not just Mexicans, or Guatemalans, or Salvadorans, or Ecuadorians; they are indigenous people, and their indigeneity is often stripped from them in the media and in public discourse. Along with their identities, their tribal knowledge systems, cultures, and worldviews are often diminished to the point that these people become externally defined as merely citizens of a larger nation. What we are trying to do is to shift that discourse just a little bit, so that people might acknowledge that these particular immigrants are indigenous people, and they might acknowledge, just for a second, that they are following the same trade and migration paths that people have followed for thousands of years. They might realise that this act of immigration, migration, movement, is not something at all new within our hemisphere. Therefore, one of our objectives with *Repellent Fence* is to connect the present with the past as part of a more holistic public memory of now.

Douglas is a border city, and a former copper-smelting town. The big black marks on the earth show where the by-products remain after the smelter is long gone. The once flourishing town now has around 17,000 inhabitants, survivors of the local mining economy apocalypse. On the Agua Prieta (Mexican) side, there are nearly 80,000 inhabitants. Due to its population, Agua Prieta is a much more vibrant city than Douglas and has a great music scene and nightlife, but is also home to the problems of maquiladoras. For many years, these two cities have been joined at the hip, and are entirely co-dependent, economically, politically, socially, and culturally. However, the region's families and histories have been divided by the intense militarisation of the border, and its destabilising affects have negatively impacted important relationships and traditions. What was once open and free-flowing is now militaristically divided.

What is not on the map is the Tohono O'odham Nation. Similar to Agua Prieta and Douglas, the border also divides the Tohono O'odham tribe from itself—its land, families, culture, religious practices, and communities. The border also creates an interesting power dynamic. When community representatives from both sides of the border get together in a room, there are clear divisions because they don't meet regularly, and the Mexican O'odham people are often excluded from American O'odham government and cultural activities. There is a political and cultural chauvinism that emerges among American O'odham people when they are in a room together. The assumption seems to be that the American O'odham people are more "Indian", for lack of a better word, and are more in touch with their knowledge and cultural systems, just because of a political demarcation. What we found, as we got to know the communities, is that it is actually quite the opposite. There are more native speakers on the Mexico side than on the US side; it's just a presumptuousness that Americans have, even within tribal communities, of this sense of legitimacy.

The original goal was to locate this project on the Tohono O'odham nation, work with the tribe, and decipher meaning and purpose for the project within that context: as a tribe of people divided by external geopolitical forces. Unfortunately, the tribe did not want anything to do with it. In these communities public discourse is shaped by tribal leadership. And in the case of the Tohono O'odham, this is very understandable because a lot of tourists

go there looking for the border, or wanting to make border art. This can be very disruptive—and as an artist you have to ask, what are you leaving behind when your project is over?

Further, US public policy has forced the American O'odham people to rely upon Homeland Security funding, as border security strategies have created a funnel of migration through the tribe's reservation. Now, the tribe pays roughly two million dollars a year just to have the trash picked up from the migrants coming across the border. The number of migrants moving through O'odham territory has also had a significant impact on tribal police and healthcare budgets, adding to the high financial stakes of the situation. The tribal government is wary of amplifying these challenges, and enabling arts discourse produced by non-community members to complicate the politics of their funding mechanisms.

So we headed east across the southern part of Arizona and the northern part of Sonora, trying to find communities interested in working with us on the project, and learning about their local community dynamics. This went on for around three to four years, with one meeting after another. We ended up going all the way to Douglas before we finally found a community that was interested. Perhaps this was because they are a small and isolated city, or because they are desperate—not desperate in terms of economics or social infrastructure, but rather in terms of wanting to achieve something that used to be taken for granted: to walk across the border and visit relatives as they did before the war on drugs became what it is today. They were basically desperate for bi-national dialogue. In fact, the two cities, Douglas and Agua Prieta, have an MOU (Memorandum of Understanding) in place to encourage bi-national dialogue whenever possible. So in this area, there are parades and community actions that stop at the border, and people meet and sit there and visit with each other. These informal actions are like "event scores"; you could even think of them as kind of a political action as these people are just trying to reconnect. We didn't find that in any other community, but we found it there.

So we started working through the formal networks. You have to work with Border Patrol, guarantee public safety, and monitor communications with the cartels if you are going to do a land art piece down there. Border Patrol has their ears open and can communicate some of the complexity that is going on. When you float a brightly coloured, 10-foot-diameter balloon 50 feet above the landscape, it can be seen from miles away, and it can create unintentional consequences. There are spotters on hills for the cartels that are watching your every move, they get on their radios to activate their networks and things can get a little dicey. So Border Patrol monitors them, and provides a bit of safety. Everybody thinks that Border Patrol is evil, but they are in a tight spot, and it is a tough job. They are working in a volatile region where there are no degrees of separation between border control, workers, and citizens—just as there are no degrees of separation between citizens and cartel representatives.

In terms of working with local government and authorised networks, we developed formal partnerships with the cities of Agua Prieta and Douglas and with ranchers to acquire their permission for property use. All of those little details need to happen, and to forge each partnership requires its own

series of meetings. This is a very bureaucratic process, very business-like, and public affairs driven. In each of those meetings, we learned a bit more about how to connect the piece of art with the realities of public policy, and the intentionalities of the community in terms of exercising their self-determination. One community meeting, in particular, stands out. A local member of the Cochise Community College art faculty—who was actually born in Agua Prieta but raised in Douglas—made an interesting comment. We were talking about the *Repellent Fence* project, what it looked like, and what it meant to us, and he stopped and said, "to me that looks like a suture", and it totally changed the dynamic of the conversation.

What started out as an ephemeral sculpture, an ephemeral monument to futility that was mocking the fence, took a step back from irony towards something very sincere that had real meaning in terms of that community's policy goals and objectives in bringing together the two towns. The people present at the meeting ran with this concept and built upon it, weaving in local meaning and levity. In terms of creating bi-national dialogues, bi-national discourse, and shared meaning, the sculpture itself emerged as a metaphor for those goals. Suddenly the *Repellent Fence* was a two-mile long "stitch": stitching the land together, stitching families together, and stitching relationships that had been severed by the wall. And suddenly, a piece that originally intended to look at how borders divide indigenous peoples from themselves, from their land, cultures, communities, and ways of living, became realised in the contemporary realities of both indigenous and non-indigenous people who were living in these two cities. It became much more dynamic and it had "teeth" all of a sudden.

From that point forward, the resources were easy to mobilise, and the community time was easier to access. Now we have teams of volunteers organised to help us install our work on the land. And we didn't have to ask for any of this—for example we met with the Agua Prieta city manager, who put us in touch with the school boards, and then the school boards told us, "Okay we've got 60 students for you that want to help." Now we literally have a four-day itinerary of community events and creative responses to *Repellent Fence*. The process will involve hundreds of people that are sincerely engaged with the community: bringing rich, local meaning to the work and advancing concepts of collaboration, self-determination, and bi-national dialogue. Our project became the community's project.

So for us, this is a social practice piece, and a land art piece. These are always intertwined, and the art of social practice from Postcommodity's perspective is realising that it is not just about making a work, or activating a space, or people. It is about working together to the point of exhaustion, at which time a kind of co-intentionality emerges; when you exhaust almost everybody in the room, you exhaust your project, you exhaust your resources, and that is when the magic, or group epiphany, happens. That experience transformed this piece from being a repellent kind of fence to being a two-mile-long political, social, and cultural "suture" for both sides of the border. The work truly became an action of interconnectedness.

Postcommodity, *Repellent Fence*, 2015. Two-
mile-long ephemeral land art installation
and social engagement. Located at Mexico-
US Border: Agua Prieta, Sonora, and Douglas,
Arizona. Courtesy the artists.

Repellent Fence: When Land Becomes Shared Metaphor

We Never Ask Why: The Failure
of Retributive Justice

Laurie Jo Reynolds

"My work addresses the classification and demonisation of people in our criminal legal system, such as "crack-moms", "super-predators", "gang-bangers", and "sex offenders", and those called the "worst of the worst". Such categories are racialised and drive extreme punishments that violate common sense and human rights—and are counter to goals of public safety. In our fanatic insistence on who these people are, we miss the fact that they are often the opposite of what we assume. Many are the most vulnerable and marginalised people in our society, sold as the most dangerous. The focus on their moral culpability masks the larger structural processes that lead to crime or criminalisation. And because these classifications produce false narratives about why crimes are committed and to whom, they also fail to address or prevent the tremendous harm that comes from violence.

In the heyday of their ostracism, people in these groups have been un-listened to, and often have lacked the social ties to listen even to each other. How would our criminal legal system be different if it were organised in order to hear the experiences and perspectives of people who have caused harm instead of subjecting them to sometimes life-long social exclusion? How do these very real people establish their political viability, especially if they have caused harm? It is helpful to think of listening as either a post-political act, where the listener listens as a result of a political discussion and decision, or a pre-political act, where the politics of the listener change because they listened.

[Tamms Correctional Center]
Tamms supermax prison was designed for one thing: sensory deprivation. The men, all in permanent solitary confinement, never left their cells except to exercise alone in a concrete pen, or in a cage if they had serious mental illness. Food was pushed through a slot in the cell door. In 2001, I organised *ASK ME!*, a live human installation during which experts sat in booths to answer questions, and the emphasis was on face-to-face communication. Participants included a voice coach, a Second World War conscientious objector, and a dominatrix. One *ASK ME!* booth was dedicated to Tamms supermax prison and the experts were family members of men in Tamms. The art apparatus provided an infrastructure for conversations and prompted curiosity. You could ask icebreaker questions such as, "Why would your loved one be called the 'worst of the worst'?"

In 2006, a group of artists started the Tamms Poetry Committee to provide the men with some social contact. We sent poems. They sent poems. The men wrote about their hallucinations, psychosis, self-mutilation, and suicide attempts, all expected consequences of solitary confinement. One man said, "Hey, this poetry is great, but could you please tell the Governor what they're doing to us down here?" We launched Tamms Year Ten (TY10), the legislative campaign to reform or close the supermax. Prison reform is hard enough, but getting politicians to stand up for people labelled "the worst of the worst" was considered hopeless. One of our organising principles was to let the men from Tamms speak for themselves. They could undo the myth of the "worst of the worst". Audiences were forced to reconcile the lingering idea of the "super-predator" with the brilliant, dear people who stood before them. The men exposed the thought error of placing them in that category.

TY10 produced cultural projects that offered different forms of knowledge about the prisoners. *Supermax Subscriptions* (a collaboration initiated by Temporary Services) allowed participants to donate frequent flyer miles to buy magazines, such as *Diabetes Forecast*, *Western Horseman*, and *Martha Stewart's Living*, for the men in solitary confinement. For *Photo Requests from Solitary*, we invited men in isolation to request photographs of anything at all, real or imagined. Ranging from practical to fantastical, the requests illustrated the visual needs and experiences of the men. Examples: "a photo of myself with a blue sky background", "my auntie's house at 63rd and Marshfield facing east", "two children at the piano with a rose", "a grey horse rearing in weather cold enough to see the breath", "J. Lo's butt", and "a photo of my mom in front of a mansion with a Hummer and money on the ground". The directedness and intentionality of these mental images pulled audiences into a new vantage point. They didn't see what the prisoners saw, but what they envisioned. Taken together, these projects provided an archive of the hopes, interests, and memories of the men in isolation. They drew people into the frame of listening.

However, the goal of a political campaign is for decision-makers to listen, and to act. Lobbying is when you seek to influence a politician, usually in the lobby of a government building. People think of lobbying as appealing to someone's worst nature. TY10 appealed to their best nature. Lobbying is listening with political consequences in mind. When we started, no one was familiar with the term "solitary"—our legislative allies were ahead of their time in taking up this issue back in 2007. With our state representatives, we held hearings, introduced legislation, worked with reporters, pulled in human rights monitors, organised lobby days, and more. Most importantly, we met with prison officials and wardens. In this process, we each put forth our views about the men in prison, their conditions, and the logic and ethics of solitary confinement. Slowly, and especially after a change of administration, our relationship improved. Under Illinois Governor Pat Quinn, the Department of Corrections was open to listening to family members, and to reason.

Our meetings had a dynamic of agonism. Disagreements were respectful and productive because we recognised each other's perspectives. We learned about the problems, pressures, and fears faced by the department as well as the difficulties and limitations of negotiating with a bureaucracy. We saw their structural obstacles as well as good faith efforts to turn the system around. In 2009, Governor Quinn appointed a new corrections chief to review the supermax and announced a ten-point plan for reform. In 2012, our Governor proposed the outright closure of Tamms, which antagonised downstate legislators who fought zealously for their prisons. We were on the same team as the Department of Corrections in accomplishing this goal. The powerful guards' union staged a fear-mongering campaign to keep the prison open (for the jobs that they weren't actually losing). A prison designed for sensory deprivation, one that drove men to self-mutilation and suicide, they said saved lives. The union responsible for this was AFSCME (American Federation of State, County and Municipal Employees), the same union that Martin Luther King, Jr marched with in Memphis in 1968 with the message that workers' rights and human rights are inseparable.

Laurie Jo Reynolds with request by Roberto Sauseda, *My photo with blue sky background*, 2012. Courtesy of *Photo Requests from Solitary*.

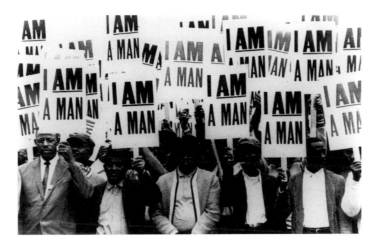

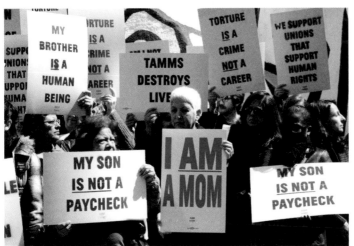

TOP Historical 1968 image of the "I AM A MAN" AFSCME protest in Memphis. Copyrighted photograph by Richard L Copley.

BOTTOM Tamms Year Ten, "I AM A MOM" March to AFSCME headquarters, 4 April, 2012. Mothers of men in isolation at Tamms supermax protest the guards' union AFSCME for supporting a prison condemned by international human rights monitors. Photo: Adrianne Dues. Courtesy Tamms Year Ten.

In response, the mothers of Tamms prisoners lobbied in Springfield, and marched to the AFSCME headquarters in Chicago. They carried special "I AM A MOM" lobbying cards and placards based on those carried by the Memphis sanitation workers. To emphasise that closing Tamms was about human dignity, not jobs, their other signs said: "My Son is Not a Paycheck" and "Torture is a Crime, Not a Career". After a long, painful test of political will, our Governor shut the supermax down. TY10 members proudly worked on Governor Quinn's re-election. The TY10 campaign used a number of proverbs. One was: "Don't romanticize, or demonize prisoners, family members, activists, prison officials, or politicians. All paths are knowable, all paths are changeable."

[The Return of the "Worst of the Worst"]
It is easier to regret bad policies of the past than to see the ones in the present. It was a feminist insight that child abuse is an endemic and entrenched pattern in families and communities. This radical critique was hijacked by news media and legislators, who persuaded us to instead focus on strangers, despite the fact that most perpetrators are known to the victim, and that some 90 per cent of new convictions come from people who are not on the sex offender registry. We should indeed prevent those listed from reoffending, but the public registry and residency restrictions instead increase the risk factors for recidivism.

In 2006, I started a listening project with people in Chicago who were on parole and on the sex offender registry in Chicago, asking questions such as: "Where do you come from?", "Who are you?", "Where are you going?" When you take the time to hear from people on the registry, you discover that life is often about losing your house and losing your job, becoming a shut-in, being afraid for your life, losing your family, dreading the future, and even being suicidal. The registry is not a coherent plan to prevent sexual violence.

Using these accounts and others, I made sex offender calling cards in homage to Adrian Piper's work. Her card reads, "Dear Friend, I am black. I am sure you did not realize this when you made/laughed at/agreed with that racist remark" and she concludes, "I regret any discomfort my presence is causing you, just as I am sure you regret the discomfort your racism is causing me." Her cards are oppositional. A person categorized as a sex offender can't afford to be.

[The Role of Listening in Retributive
Vs Transformative Models of Justice]
The US criminal legal system is characterised by an absence of listening. "Where do you come from? Who are you? Where are you going?" We don't ask. Instead we make colossal investments in policies to exclude huge categories of people from our community and from human contact. In prison, we call people "populations". In order to consider someone as an individual, you need their prison identification number. When addressing them directly, staff say, "Offender Jones" as if by existing they are always actively offending. When someone who causes harm is sent through the criminal legal system, we calcify that event and crystallise their entire life around it. For this there are trillion dollar costs and existential costs. We shifted into a new way of

interacting with and perceiving human beings and other animals: as actuarial risks, profits, objects of surveillance, and as more deserving of a lifetime banishment than support, treatment, or engagement.

This framework is an extension of our retributive system of justice, where crime is considered an act against the state, and the goal is to assign guilt and punish those who break the law. It's an adversarial system, administered by professional proxies for those directly involved, and for the state. Because the focus is on convicting, there is no structured interest in listening to or understanding the experiences of those directly involved. In this case, not listening is the post-political act. The system is indifferent, if not outright vengeful, toward those accused or convicted of crimes, and has little motivation to attend deeply to the needs of victims.

But there are other models, such as restorative and transformative justice, premised in listening to victims and perpetrators. In these paradigms, which have emerged from peacemaking criminology and derived from indigenous practices, crime is viewed as an act against another person and the community. The focus is not on punishment, but on taking responsibility for harm and repairing these relationships through intense dialogue and action. For restorative and transformative justice practitioners, listening is a post-political act: the perpetrator is already assumed to be capable of accountability and reparation, and therefore worthy of sustained attention. It is simultaneously pre-political: the act of listening transforms everyone involved, potentially the whole community. Crime is understood as a failure of society, not just individuals, and the examination of individual crimes can also illuminate the structural economic and social conditions that influence one person to harm another. In contrast, our retributive system strips individuals in the criminal justice system of their dignity, while also exacerbating structural inequality. After all, mass incarceration has decimated poor communities, which already have high rates of crime and victimisation, without making them safer.

[The Potential of Listening]
At Tamms supermax prison, opened in 1998, the notion of "the worst of the worst" was used to justify isolation, a practice that was all but shunned for 100 years in US correctional history because of the known mental damage it caused. Because we let it, long-term solitary confinement became a normal feature of incarceration. Public registries also resurfaced and escalated in the 1990s, under false assumptions about their usefulness. Registries quickly became a new normal of the criminal legal system. Illinois, for example, now has public registries for meth, murder, and violent crimes against youth, as well as a site to publicly shame "johns" (people arrested for soliciting sex), and a law enforcement database for purchasers of cold medicine. There are also countless restrictions and prohibitions in jobs, education, and housing, as well as geographic zones to exclude people from living, working, or being there at all.

The US prison population has increased 500 per cent since 1970, and the 1990s were the most punishing decade in history. Yet throughout this era, and until very recently, there was little public conversation about the injury caused by both crime and incarceration to individuals, families, or

communities. The press and politicians shamed incarcerated people and their families, and the public followed suit. For years, the stigmatisation of people with sex offenses has been so absolute and compelling that progressives of every stripe have remained silent, as well as professionals in the field, including therapists, treatment providers, and prisoner advocates. Even Critical Resistance, the radical prison abolition organisation, omitted mention of sex offenders at both their inaugural and ten-year anniversary conferences, even though panic about people with sex offenses had already transformed the criminal justice landscape. Ironically, it was law enforcement, child advocates, victims groups, legislators, and even prosecutors who first offered objections to sex offender restrictions, presumably because their contact with the real people to which these laws apply led them to see that these responses were not improving public safety.

Now, from the Koch brothers to John Legend, there is an unprecedented consensus that harsh punishments have been a moral and fiscal catastrophe. Still, many reformers focus on the "innocent" in prison, such as "non-violent drug offenders" pitting them against those labelled the "worst of the worst"— precisely the approach that has escalated incarceration and has enabled myths to thrive. The overwhelming majority of people on the registry will not commit a new sex crime, and people who have committed murder are the least likely of all to reoffend. Yet, there is currently little in our culture— except perhaps the arts—to show how their reintegration and forgiveness might happen, or to say, "You are still part of our society. We want to help you stay on the right path."

An enduring example of the value of listening—and a touchstone for many in the transformative justice movement—is the intervention taken in the 1980s by Hollow Water, an Anishinaabe (Ojibwa) First Nation north of Winnipeg. Upon recognising that they had astronomically high numbers of victims of sexual abuse as well as abusers, they were prepared to take action. But they determined that the retributive system of justice, and its attendant incarceration, would be at odds with the community's primary need for healing and reparation. Thus, Hollow Water used their sovereign status to negotiate a new relationship with the courts, police and child protective agencies. They instituted a comprehensive programme of accountability, treatment, and restoration by holding community circles for both the victims and perpetrators. These were paradigms of listening, hearing, and taking responsibility. There was no shaming. Instead, the entire community took responsibility for the crimes. In only a decade, they brought sex offending rates down to two per cent recidivism. Through rigorous listening, they created a cycle of prevention. "

Dear Friend,
 I am black.
 I am sure you did not realize this when you made/laughed at/agreed with that racist remark. In the past, I have attempted to alert white people to my racial identity in advance. Unfortunately, this invariably causes them to react to me as pushy, manipulative, or socially inappropriate. Therefore, my policy is to assume that white people do not make these remarks, even when they believe there are no black people present, and to distribute this card when they do.
 I regret any discomfort my presence is causing you, just as I am sure you regret the discomfort your racism is causing me.
 Sincerely yours,
 Adrian Margaret Smith Piper

Dear Friend,
 I am a registered sex offender.
 I am sure you did not realize this when you stated that all sex offenders should have their balls cut off/be castrated/be raped/be killed, etc.
 That said, I do understand why there is so much hatred directed at sex offenders.
 There is a lot that could happen at this point.
 I could correct any misconceptions you have about sex offenders. I could give you information about my offense. I could explain why many sex offender laws are counter-productive to public safety.
 I respect your decision and wish you the best.

TOP Adrian Piper, *My Calling (Card) #1 (for Dinners and Cocktail Parties)*, 1986–1990. Performance prop: business card with printed text on cardboard. 3.5 x 2 in (9 x 5.1 cm). Collection Adrian Piper Research Archive Foundation Berlin. © APRA Foundation Berlin.

BOTTOM Laurie Jo Reynolds, *Sex Offender Calling Card*, 2008–present. Union-printed card. 2.5 x 3 in (6.3 x 7.6 cm). Courtesy the artist

Contributors

Lawrence Abu Hamdan is a multi-media artist with a background in DIY music. In 2015, he was the Armory Show commissioned artist and participated in the New Museum Triennial. The artist's forensic audio investigations are made as part of the Forensic Architecture research project at Goldsmiths College, University of London, where he is also a PhD candidate and associate lecturer. Recent exhibitions include solo shows at institutions such as The Showroom, London; Casco, Utrecht; Beirut, Cairo; Kunsthalle St Gallen; and forthcoming at the Museum of Modern Art, New York.

Anne Barlow is Director of Art in General, New York where she most recently curated exhibitions with Marwa Arsanios, Basim Magdy, Jill Magid, Shezad Dawood, Meriç Algün Ringborg, and Anetta Mona Chisa and Lucia Tkáčová, and launched Art in General's International Collaborations programme and What Now? symposium. Barlow was formerly Curator of Education and Media Programs at the New Museum, New York, where she organised numerous exhibitions and initiated and developed its Museum as Hub programme. She has published with The Pew Center for Arts & Heritage, Philadelphia; the New Museum, New York; and Tate Modern, London, among others, and has lectured or moderated talks at organisations including ArteEast, New York; Centre for Contemporary Art, Warsaw; MUMOK, Vienna; IASPIS, Stockholm; and the Sharjah Art Foundation, UAE. Barlow was Curator of Tactics for the Here and Now, the 5th Bucharest Biennale, Romania, 2012, and Co-Curator of the Latvian Pavilion at the 55th Venice Biennale, 2013.

Grégory Castéra served as Co-Director of Les Laboratoires d'Aubervilliers from 2010 to 2012. Over this period he conducted various research projects on discourse formation within artistic practices, giving rise to publishing projects, shows, events, and exhibitions. Since 2007, he has also co-authored the *Encyclopédie de la parole* (Encyclopaedia of speech), a collaborative inquiry into the formal properties of speech. In 2010, he initiated Ecologies, a programme on the creation of tools for representation of art as an ecology (awarded the Hors les Murs grant by the Institut Français in 2013). He holds a Bachelor degree in Economics (University of Tours) and a Masters in Design and Implementation of Cultural Projects (Sorbonne, Paris).

Christoph Cox is Professor of Philosophy at Hampshire College and visiting faculty at the Center for Curatorial Studies, Bard College. He is the author of *Sonic Flux: Sound, Art, and Metaphysics* (forthcoming) and *Nietzsche: Naturalism and Interpretation* (California, 1999), and co-editor of *Realism Materialism Art* (Sternberg, 2015) and *Audio Culture: Readings in Modern Music* (Continuum, 2004). The recipient of an Arts Writers Grant from Creative Capital/Warhol Foundation, Cox is editor-at-large at *Cabinet* magazine. His writing has appeared in *October*, *Artforum*, *Journal of the History of Philosophy*, *The Wire*, *Journal of Visual Culture*, *Organised Sound*, *The Review of Metaphysics*, and elsewhere. He has curated exhibitions at the Contemporary Arts Museum Houston; The Kitchen, New York; New Langton Arts, San Francisco; and G Fine Art Gallery, Washington DC.

Joshua Craze is a writer and Assistant Professor at the University of Chicago. He was a UNESCO-Aschberg artist laureate in creative writing in 2014. He has published work in *The Washington Monthly*, the *Guardian*, the *Institute of War and Peace Reporting*, and elsewhere, and he has exhibited his writing on redacted documents at the New Museum, New York. He has also worked in South Sudan as a researcher for Small Arms Survey and Human Rights Watch.

ESTAR(SER) The Esthetical Society for Transcendental and Applied Realization (now incorporating the Society of Esthetic Realizers) is an established body of independent scholars, amateurs, and interested parties who work collectively to recover, scrutinise, and (where relevant) draw attention to the historicity of "The Order of the Third Bird". Associated researchers sift the historical record for evidences of bird-like attentional practices, and present their findings to critical readers. In this ongoing project the ESTAR(SER) community is fortunate to be in possession of an extensive body of source materials—known as "The W Cache"—which appears to have been assembled by an aspiring historian of the Order seeking to write a comprehensive history of its activities. He or she did not succeed, but bequeathed to the Society a diverse archive. The academicians of ESTAR(SER) have made it their business, over the years, to publish critical editions of these primary sources, materials that see print in the Proceedings of ESTAR(SER). Offprints and other communiqués can be found at www.estarser.net

Seeta Peña Gangadharan is a Program Fellow at the New America's Open Technology Institute (OTI) and Assistant Professor in the Department of Media and Communications at the London School of Economics and Political Science. Her work lies at the intersection of technology, civil society, and communication policy. She focuses on the nature of digital inequalities, data and discrimination, social dynamics of technology adoption, communication rights, and media justice. She has written and spoken widely about digital inclusion, privacy, surveillance, and data profiling of marginalised populations. Her work has identified privacy and surveillance norms and practices among members of underserved groups and exposed the lack of privacy and surveillance knowledge among frontline staff at digital literacy organisations. She has also compared current-day data profiling to pre-digital examples of surveillance of poor people and communities of colour.

Lauren van Haaften-Schick is a curator, writer, and artist working towards a PhD in Art History at Cornell University studying the intersection of art and law, and histories of artists' labour, economic, and property rights. Her research focuses on Seth Siegelaub and Robert Projansky's *The Artists' Reserved Rights Transfer and Sale Agreement* from 1971, and its origins and legacies in artistic, political, and juridical spheres. Exhibitions include Canceled: Alternative Manifestations & Productive Failures at The Center for Book Arts, New York, Smith College, Massachusetts, among others (2012–2014), and Non-Participation at The Luminary, Missouri, and the Art League Houston (2014–2015). Recent publications, workshops, and lectures include "Cariou v. Prince: Toward a Theory of Aesthetic-Judicial Judgments" (with Sergio Muñoz Sarmiento) in the *Texas A&M Law Review*, "Valuing Labor in the Arts" at the Arts Research Center,

UC Berkeley; and "Conceptual to Legal: The Siegelaub-Projansky Agreement" at the Law, Culture, and the Humanities conference, Georgetown University.

Pablo Helguera often draws improbable relationships between human histories, biographies, anecdotes, and historical events, always bringing them together in a cohesive whole and making all serve as a reflection on our current relationship with art as a society. Helguera often focuses on history, pedagogy, sociolinguistics, and anthropology in formats such as lectures, museum displays, performance, and written fiction. His project *The School of Panamerican Unrest*, 2003–2011, an early example of pedagogically-focused socially engaged art, consisted of a nomadic think-tank that physically crossed the continent by car from Anchorage to Tierra del Fuego. Helguera has exhibited widely and internationally and he is the author of several books including *Art Scenes: The Social Scripts of the Art World*, 2012, a book on the sociology of contemporary art; *Education for Socially Engaged Art: A Material and Techniques Handbook*, 2011, a primer for social practice; *What in the World: A Museum's Subjective Biography*, 2010; *Theatrum Anatomicum (and other performance lectures)*, 2009; and *The Pablo Helguera Manual of Contemporary Art Style*, 2007.

AJ Hudspeth conducted undergraduate studies at Harvard College and received PhD and MD degrees from Harvard Medical School. Following postdoctoral work at the Karolinska Hospital in Stockholm, he served on the faculties of the California Institute of Technology, the University of California, San Francisco, and the University of Texas Southwestern Medical Center. After joining Howard Hughes Medical Institute, Hudspeth moved to The Rockefeller University, where he is the FM Kirby Professor and Head of the Laboratory of Sensory Neuroscience. Hudspeth conducts research on hair cells, the sensory receptors of the inner ear. He and his colleagues are especially interested in the active process that sensitises the ear, sharpens its frequency selectivity, and broadens its dynamic range. They also investigate the replacement of hair cells as a potential therapy for hearing loss. Hudspeth is a member of the National Academy of Sciences and the American Academy of Arts and Sciences.

Naeem Mohaiemen works on projects on borders, wars, and belonging within Bangladesh's two postcolonial markers (1947 and 1971). In 2014, a survey show and publication, *Prisoners of Shothik Itihash*, brought these projects together at Kunsthalle Basel. He also researches the 1970s revolutionary left in the project *The Young Man Was*. Chapters include the films *United Red Army*, 2011, about a 1977 plane hijack; *Afsan's Long Day*, 2014, which turned a case of mistaken identity with the afterlives of Rote Armee Fraktion; and *Last Man in Dhaka Central*, 2015, about a Dutch man arrested after the 1975 military uprisings, which premiered at the 2015 Venice Biennale. Historian Afsan Chowdhury (the namesake of the 2014 film) has bracketed Mohaiemen, Mukherjee, D'Costa, Siddiqi, and Saikia as a "second wave of history writing" about Bangladesh. Naeem is a PhD student in Historical Anthropology at Columbia University and a 2014 Guggenheim Fellow (film).

Beatriz Santiago Muñoz is an artist and a co-founder of Beta-Local, an artist-run space in San Juan, Puerto Rico. Her work arises out of long periods of observation and documentation, in which the camera is present as an object with social implications and as an instrument mediating aesthetic thought. Her films frequently start out through research into specific social structures, individuals, or events, which she transforms into performance and moving image. Santiago Muñoz's recent work has been concerned with post-military land, Haitian poetics, and speculative futures. Recent exhibitions

include: La Cabeza Mató a Todos, TEORética, San José, Costa Rica; MATRULLA, Sala de Arte Público Siqueiros, Mexico City; Under the Same Sun, Solomon R Guggenheim Museum; Post-Military Cinema, Glasgow International; and The Black Cave, Gasworks, London. She is a recipient of a 2015 Creative Capital Visual Arts Award. Her work is in the collections of the Solomon R Guggenheim Museum and Bronx Museum as well as other private and public collections.

Laurie Jo Reynolds is an artist and policy advocate. She was the organiser for Tamms Year Ten, a grassroots campaign to close the notorious state supermax prison in Tamms, Illinois, shuttered in 2013 by Governor Pat Quinn. As a 2010 Soros Justice Fellow, Reynolds researched best practices to stop sexual abuse and reduce recidivism, creating functional and dialogical art to support policy change. She recently produced work for Citizen Culture: Art and Architecture Shape Policy, Santa Monica Museum of Art; A Proximity of Consciousness, Sullivan Galleries, Chicago; and Museum of Arte Útil, Van Abbemuseum, Eindhoven, the Netherlands. Reynolds is the recipient of a Creative Capital grant, a Blade of Grass fellowship, and the Lenore Annenberg Prize for Art and Social Change. In 2014, she was on the staff of Governor Quinn's re-election campaign. She is now Assistant Professor of Public Arts, Social Justice, and Culture at the University of Illinois at Chicago.

Robert Sember is a member of the international sound-art collective, Ultra-red. For 20 years, Ultra-red has investigated the contribution experimental sound art can make to political organising. Robert brings to his work with Ultra-red training in cultural studies and medical anthropology. His ethnographic research in the US and South Africa has focused on governmental and non-governmental service sectors with an emphasis on HIV/AIDS prevention, testing, and treatment concerns. He currently teaches at The New School's Eugene Lang College. He was a 2009–2010 Vera List Center for Art and Politics Fellow.

Kade L Twist is an interdisciplinary artist working with video, sound, interactive media, text, and installation environments. Twist's work combines reimagined tribal stories with geopolitical narratives to examine the unresolved tensions between market-driven systems, consumerism, and American Indian cultural self-determination. Twist is one of the co-founders of Postcommodity, an interdisciplinary artist collective. On 9–12 October, 2015, Postcommodity staged *Repellent Fence*, a two-mile-long land installation intersecting the Mexico-US border near Douglas, Arizona, and Agua Prieta, Mexico. In addition to his art practice, Twist is also a public affairs consultant specialising in American Indian health care, technology, and community development. Twist received his MFA in Intermedia from the Herberger Institute School of Art at Arizona State University. He is an enrolled member of the Cherokee Nation of Oklahoma.

Sandra Terdjman is co-founder of Kadist Art Foundation—a private foundation based in Paris and San Francisco, dedicated to supporting contemporary art. From 2006 to 2012, as Artistic Programme Director at Kadist Art Foundation (Paris), she developed a residency programme for international artists and curators, overseeing the production of a series of works, films, performances, and exhibitions. Presently, she serves as advisor for the Kadist Art Foundation on collection acquisition, production, and dissemination. She holds a Bachelor degree in Art History (Sorbonne, Paris), a Masters in Creative Curating (Goldsmiths College, London) and has participated in the experimentation in art and politics programme run by Bruno Latour (Sciences Po The Paris Institute of Political Studies).

Acknowledgements

On behalf of Art in General, I would like to thank Carin Kuoni, Director and Curator of the Vera List Center for Art and Politics, for her pivotal role in not only hosting the symposium as our educational partner, but also for her active contribution as one of the key advisors to the conceptual development of the symposium. I would also like to acknowledge the significant contributions of What Now? 2015 advisors Regine Basha, Pablo Helguera, and Wato Tsereteli, who helped shape the format and content of the programme.

While this book brings together a selection of transcripts from the symposium alongside commissioned essays around specific topics, Art in General would like to thank all participants in the What Now? The Politics of Listening symposium for their insightful presentations and artistic contributions.

I would also like to thank the Board of Art in General and the staff, in particular my colleagues Lindsey Berfond and Kristen Chappa, for their skilful editorial assistance on the publication, and Regis Trigano and Alon Koppel for designing and implementing a dedicated What Now? website at http://whatnowsymposium.org/ that will document each symposium and provide a platform for expanded content beyond the event itself.

Art in General would like to acknowledge the invaluable support of the Institute of Museum and Library Services for its three-year funding of the What Now? symposia and book series from 2015 through 2017 through its grant MA-10-14-0304-14. Art in General would also like to thank the Lambent Foundation and the Trust for Mutual Understanding for their generous support of the 2015 symposium.

Anne Barlow, Director, Art in General

Art in General was founded in Lower Manhattan in 1981 and supports the production of new work by local and international artists primarily through its New Commissions Program and its International Collaborations programme. Since 2014, Art in General has produced, in collaboration with the Vera List Center for Art and Politics, an annual symposium What Now? on critical and timely issues in artistic and curatorial practice.

General support of Art in General is provided by General Hardware Manufacturing Inc.; the Institute of Museum and Library Services; the Lambent Foundation; the New York State Council on the Arts with support of Governor Andrew Cuomo and the New York State Legislature; Ruth Ivor Foundation; The Greenwich Collection; Milton and Sally Avery Arts Foundation; Cowles Foundation; Toby D. Lewis Donor Advised Fund of the Jewish Federation of Cleveland; the William Talbott Hillman Foundation; and by private individuals. This programme is also supported, in part, by public funds from the New York City Department of Cultural Affairs in partnership with the City Council.

The New Commissions Program is made possible by the Andy Warhol Foundation for the Visual Arts; the Trust for Mutual Understanding; the National Endowment for the Arts; the Jerome Foundation, and the Milton & Sally Avery Foundation. Support has also been provided by Commissioners' Circle leaders Jeffery Larsen and Joseph Bolduc; Commissioners' Circle supporter Cher Lewis, and Commissioners' Circle members Roya Khadjavi-Heidari, Mary Lapides, Richard Massey, Ron and Lucille Neeley, and Leslie Ruff.

This project was made possible in part by the Institute
of Museum and Library Services through its grant MA-
10-14-0304-14. The views, findings, conclusions, or
recommendations expressed in this series of symposia and
corresponding publications do not necessarily represent
those of the Institute of Museum and Library Services.

Black Dog Publishing Limited
10a Acton Street, London WC1X 9NG
United Kingdom

Tel: +44 (0)20 7713 5097
Fax: +44 (0)20 7713 8682
info@blackdogonline.com
www.blackdogonline.com

British Library Cataloguing-in-Publication Data.
A CIP record for this book is available from the British Library.

ISBN 9781910433577

Designed by Sylvia Ugga at Black Dog Publishing.

Black Dog Publishing Limited, London, UK, is an
environmentally responsible company. *What Now? The Politics
of Listening* is printed on sustainably sourced paper.

art design fashion
history photography
theory and things

www.blackdogonline.com